# ARTISTS' CORNER
## OF ST PAUL'S CATHEDRAL

SIMON CARTER

SCALA

St PAUL'S
CATHEDRAL

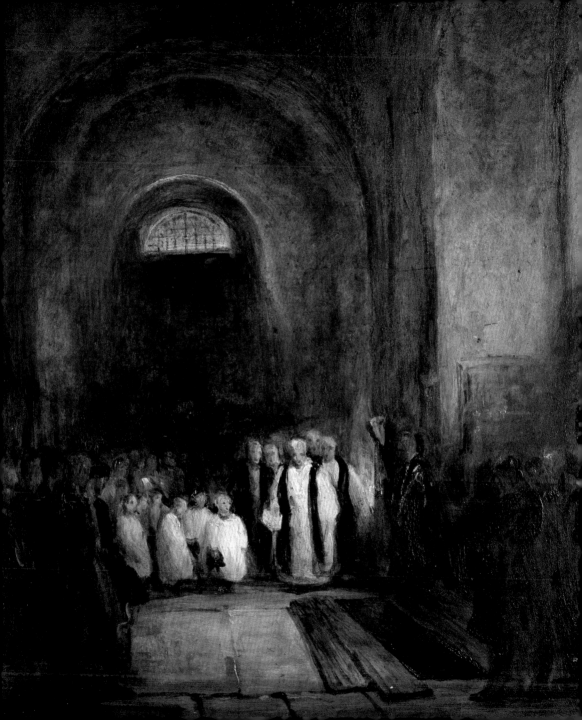

# CONTENTS

*Turner's Burial in the Crypt of St Paul's* by George Jones, after 1851 (Ashmolean Museum, Oxford)

# INTRODUCTION

EARLY in his career J.M.W. Turner added his own tombstone to a watercolour he was painting of the interior of Westminster Abbey. He placed himself in what was traditionally the last resting place of English 'greats'. By the time he died in 1851, however, a corner of the crypt of St Paul's Cathedral had become firmly established as the place of commemoration for the geniuses of British art, particularly those associated with the Royal Academy of Arts. Turner was interred there at his own request to 'be among his brother artists'. He lies surrounded by monuments and memorials to some of the most famous painters and sculptors of the eighteenth and nineteenth centuries, including Joshua Reynolds, William Holman Hunt and John Singer Sargent. Their tomb slabs and wall plaques, most densely clustered in the south-east corner of the crypt, occupy a prestigious space around the grave of Christopher Wren, the architect of St Paul's, still one of the most visited spaces in the cathedral. This area has become known as Artists' Corner.

Over forty artists are now commemorated in the crypt while three have monuments on the cathedral floor. Spanning the period 1649–1995, the group includes many presidents of the Royal Academy, several artists who held significant positions at the Academy, and others who arrived owing to popular demand or the efforts of dedicated supporters. Some artists buried elsewhere received a memorial in St Paul's soon after they died and other plaques were added later, when the genius of the artists was more widely appreciated.

This remarkable corner exists largely because of the relationship between St Paul's and the Royal Academy, which was founded in 1768 with a mission to establish a British School of Painting and Sculpture through expert teaching and exhibitions. The Academy aimed to enhance the prestige of the monarch, the nation and the role of the artist. It provided lessons at the Royal Academy Schools and a hierarchical structure, with Associates (ARAs) and full members or Academicians (RAs). The headquarters from 1775 to 1830 were at New Somerset House, less than a mile to the west of the cathedral.

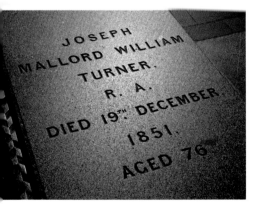

Turner's grave marker

The connection with St Paul's began when the Academy proposed having altarpieces by six of its members installed in the cathedral. Reynolds, the instigator of the plan, also hoped to extend the scheme to include monuments. The altarpiece proposal failed, but in 1791 the Academy provided a committee to supervise the commission of the first monuments for the cathedral floor. The government's Treasury Department would later take control of the process but the link between the two institutions had been established and was cemented by the request in Reynolds's will to be buried in St Paul's, a wish approved by King George III, patron of the Academy.

Why did Reynolds choose St Paul's? By the end of the eighteenth century Westminster Abbey was considered full and, according to Dean Milman's history, compromised by 'many bad fantastic monuments'. Meanwhile, St Paul's, partly thanks to Reynolds's efforts, was developing a role as a repository for examples of national heroism. The magnificent architectural setting no doubt appealed to Reynolds's sense of occasion. It may also have been significant that Anthony Van Dyck, court painter to Charles I, whose work Reynolds admired, was buried in Old St Paul's (lost in the Great Fire of London) and commemorated in the choir of that building with a statue depicting the muse of painting.

Artists' Corner looking west

With the early mission of the Academy to establish a British school of art, and the role of St Paul's as a national pantheon, the international origin of some of the occupants of Artists' Corner may come as a surprise. However, by 1851, the year in which Turner arrived, the list already included an American, an Irish and a Swiss artist, and this list would subsequently include Austro-Hungarian, Dutch and Scottish artists who all helped to shape the development of art in Britain. Almost all of those in Artists' Corner rooted their work in the wider European tradition and travelled far to learn from their Continental peers and predecessors.

Some of these individuals were wildly successful in their own lifetime, while others died in poverty and obscurity. They include radicals and conservatives, bohemians and conformists, adherents of various Christian denominations and

atheists too. With origins, personalities and lives as different as the subjects they chose to paint and the styles they developed, they are united in Artists' Corner by their contribution to the visual arts in Britain. Many of those commemorated had been close friends in life who studied and worked together, competed against each other and attended memorial services at St Paul's for their colleagues and associates.

The funerals of the biggest names were some of the grandest the cathedral has seen, attended by royalty or their representatives, ambassadors from foreign nations, the Lord Mayor and cohorts of fellow artists. Typically, lying in state was followed by a hierarchical coach procession and, such was the celebrity of the artists, City of London constables attended to maintain order among the curious thousands who lined the streets. The cortège was met at the cathedral's great west doors by the clergy, before mourners moved to a service beneath the dome or in the quire, after which the coffin was lowered through an aperture to the crypt below. The size and spectacle of these events dwindled in the twentieth century as the influence of the Academy waned and artists depended less on association with the establishment. Grand ceremonial was replaced with more modest dedication ceremonies held next to the monuments in the crypt.

The memorials range from simple grave ledgers to elaborate mixed-media wall plaques and free-standing statues. Many are by important sculptors, the lettering

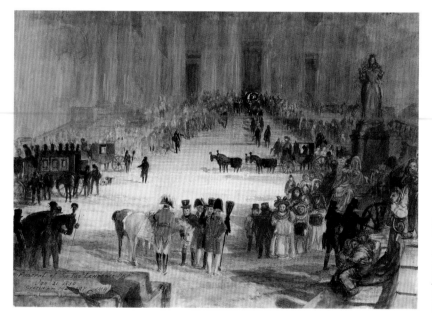

Funeral of Sir Thomas Lawrence: A Sketch from Memory by J.M.W. Turner, watercolour, 1830 (Tate Britain)

of the inscriptions as much the result of carefully designed and executed craftsmanship as the carved or cast elements. Several of the ledgers feature spectacular decorative brass work and a number of the wall plaques make reference to the most famous works of the artists they commemorate. With these evocative memorials and Wren's grave located close by, this part of the crypt has been a place of interest since the eighteenth century and guidebooks have consistently drawn attention to Painters' or Artists' Corner.

This guide brings together all the painters and sculptors buried and/or commemorated in the cathedral. It omits the architects commemorated through their presidency of the Royal Academy; nor does it include the artists responsible for the building's most significant artistic embellishments, who are notably absent from Artists' Corner. Also missing are successful female artists, who were mostly excluded from societies and associations. However, one talented female painter and sculptor did influence the development of Artists' Corner: Princess Louise, the daughter of Queen Victoria, was a friend to many of the artists who were her contemporaries and an advocate for their memorials in the cathedral.

Artists' Corner thus celebrates the lives of a fraternity of artists who contributed to raising the status of British art: the group of brothers whom Turner sought to be among, who strove for artistic excellence with talent and ambition. The pages that follow provide a glimpse of those men and their work that, more than the brief inscription on their ledgers, is their true memorial. Artists' Corner underpins the cathedral's ongoing relationship with the art world in pursuit of its mission of Christian worship and is a reminder of the importance of Britain's cultural links with the wider world.

# SIR ANTHONY VAN DYCK
## 1599–1641

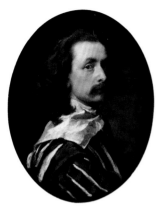

VAN Dyck established an excellence in portrait painting in England that has inspired generations of British artists. His skills were rooted in a deep knowledge of the art of Continental Europe and experience producing altarpieces, portraits and mythical and literary scenes for courtiers and wealthy merchants. He travelled restlessly and enjoyed the trappings of success.

Born in Antwerp, he was apprenticed at a young age to the painter Hendrick Van Balen. He soon established his own studio while also working for Peter Paul Rubens, emulating his style and developing his own methods and approach. His first visit to England was short but he obtained royal patronage before departing to Italy. There he painted the mercantile families of Genoa before proceeding to Rome, Venice and Sicily, studying and collecting old masters as he went. On returning to Flanders he painted religious subjects and courtiers in The Hague.

1632 was a good year for Van Dyck. Revisiting London, he immediately received commissions from King Charles I, was knighted, became 'principalle Paynter in Ordinary' to the King and Queen and was given a house in Blackfriars. The following year he was granted a pension of £200 per annum. The productive and lucrative London studio he established was constantly busy, serving royalty and the aristocracy.

He died in Blackfriars on 9 December 1641 and was buried two days later in Old St Paul's Cathedral at his own request. A monument erected in the cathedral by the King's order, representing the Genius of Painting, the left arm leaning on a skull, and looking at his own face in a mirror, was destroyed in the Great Fire of London. The idea of commemorating the artist in the present St Paul's emerged in 1900, at the time of an exhibition at the Royal Academy. Taking inspiration from a monument in the Dutch Church Austin Friars, the monument was unveiled in the crypt by Frank Dicksee on 22 March 1927, a gift of J.G. Simpson, Canon of St Paul's 1912–28.

*Self Portrait*, about 1640 (National Portrait Gallery)

Monument designed by Mervyn Macartney, and sculpted by Henry Poole, freestone, 1927

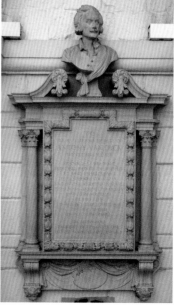

*Charles I*, 1635 (Royal Collections Trust)

# SIR JOSHUA REYNOLDS
## 1723–1792

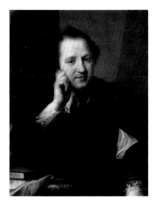

THE most innovative portrait painter of his generation, Reynolds became the first President of the Royal Academy where, through unswerving ambition and wide-ranging abilities, he founded a British School of Art. He elevated the status of art and artists in national prestige, while obtaining considerable wealth and standing.

He studied the theory of painting at his father's grammar school in Plympton, Devon, before beginning an apprenticeship with the artist Thomas Hudson. The works of his early career, as he gradually surpassed his master, show the influence of Rembrandt and Van Dyck. Reynolds ended the partnership to travel extensively in Italy, studying the paintings of the sixteenth and seventeenth centuries and on his return took a keen interest in plans for a Royal Academy of Arts. He accepted the role of President of the new institution in 1768 and was knighted the following year.

Portrait by Angelica Kauffmann, 1767, detail (National Trust, Saltram)

Grave ledger by an unknown artist

Reynolds produced portraits for friends (such as the portrait of the man thought to be Francis Barber, servant of Samuel Johnson), aristocrats, actors, scientists and clergymen, as well as history paintings and studies of children. His style could be formal or informal according to the taste of his sitters and, when possible, he combined portraiture and history painting, aiming at a timeless 'Great Style'. His lectures, or 'Discourses', set out his views on art theory and practice. They dealt with concepts such as genius, originality, imitation and taste and the public benefit of art as a glory of the nation. The last word of his final Discourse was, pointedly, 'Michelangelo'.

In 1789 his retirement from painting, owing to his poor eyesight, was announced in the press, a reflection of his public profile. Shortly afterwards, incurable liver disease, initially dismissed as hypochondria, was discovered. He died at home on 23 February 1792. Reynolds had made two stipulations about his funeral: that it should be as inexpensive as possible, and that

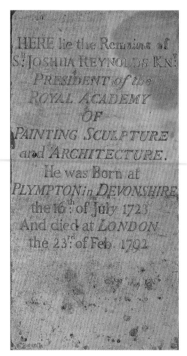

HERE lie the Remains of Sʳ JOSHUA REYNOLDS Kⁿᵗ PRESIDENT of the ROYAL ACADEMY OF PAINTING SCULPTURE and ARCHITECTURE. He was Born at PLYMPTON in DEVONSHIRE the 16ᵗʰ of July 1723 And died at LONDON the 23ʳᵈ of Feb. 1792

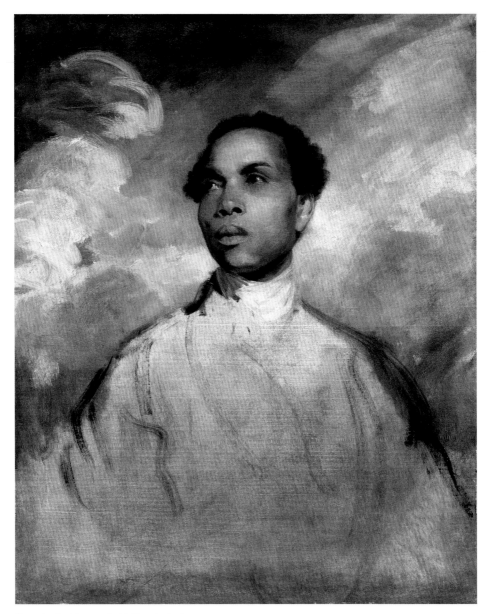

*Portrait of a Man, probably Francis Barber,*
1770 (Menil Collection, Houston, Texas)

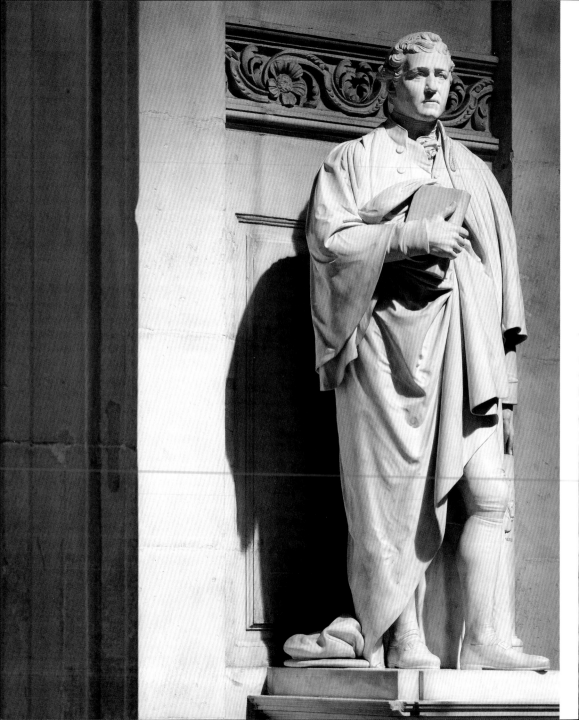

he should be buried at St Paul's. His executors strove to fulfil the second of these, assisted by 48 Academicians who contributed to the expense.

After lying in state at Somerset House by special consent of King George III, his body was carried to St Paul's in a hearse accompanied by 91 carriages. The procession was led by the Lord Mayor of London, while members of the public lined the streets and hung from windows to watch. The coffin was carried into the cathedral by pall-bearers who were all peers of the realm. It rested in the quire during the service before being lowered to the crypt and interred near to Christopher Wren.

In 1813 a monument to Reynolds was placed at the base of the cathedral's north-west pier. The Royal Academy had refused to contribute to the cost and it was commissioned by his niece and heiress. John Flaxman produced the sculpture, representing the artist in his Doctor of Law gown; his right hand holds his *Discourses on Art* and his left rests on a pedestal above a profile of Michelangelo. The Latin inscription provided by Richard Payne Knight, a connoisseur, classical scholar and fellow art theorist, translates as follows:

> *Joshua Reynolds, the first painter of his age, and in the brightness and harmony of his colouring, mutually exciting the varieties of light and shade, second to none of the ancient masters; who, possessing the highest glories of his profession became still farther estimable by the suavity of his manners, and the elegance of his life; who found art languishing and nearly exhausted upon the earth, revived its charms by the most beautiful exertions, illustrated its rules by the most exquisitely written precepts, and bequeathed it to the emulation of posterity, corrected and polished; this statue was placed by the friends and fosterers of his fame, in the year of salvation 1813*

Monument by John Flaxman,
marble, 1813

# JAMES BARRY
## 1741–1806

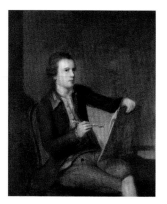

A notoriously belligerent artist, Barry pursued an uncompromising enthusiasm for biblical, mythological and historical scenes despite the hostile cultural, political and commercial currents of his time. The only member expelled from the Royal Academy (until 2004), his controversial views were considered a threat to the political and artistic status quo.

Born in Cork, he trained and exhibited in Dublin before moving to London in 1764. The generosity of his friend the philosopher Edmund Burke enabled him to study for five more years, primarily in Paris and Rome. On his return to Britain he was elected an Academician and went on to be appointed Professor of Painting in 1782.

He was not prolific, producing 20 history paintings and 13 portraits in his lifetime; however, his series of six mural paintings depicting *The Progress of Human Culture and Knowledge*, created for the Royal Society of Arts, is a masterpiece. It is a complex allegorical work, for which he was given complete control of the subject matter. The scheme is so richly populated with hundreds of historical and contemporary portraits that he was compelled to provide a 221-page explanation to accompany it.

Barry's involvement in the unsuccessful proposal to decorate St Paul's with paintings precipitated a rift between him and Reynolds, who had initiated the plan. The two remained at odds until Reynolds resigned from his position as President of the Royal Academy. Barry sympathised with Reynolds's stand against chauvinism in the appointment of Associates of the Academy and was himself expelled from the Academy in 1799 after a sustained attack on the leadership.

His later years were reclusive and marked by poor mental health.

*Self Portrait,* 1774–98 (Royal Society of Arts)

Wall monument probably modelled by Joseph Panzetta after a design by W. Evans and made by Coade of Lambeth, coade stone, 1818

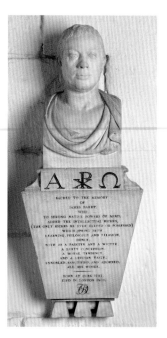

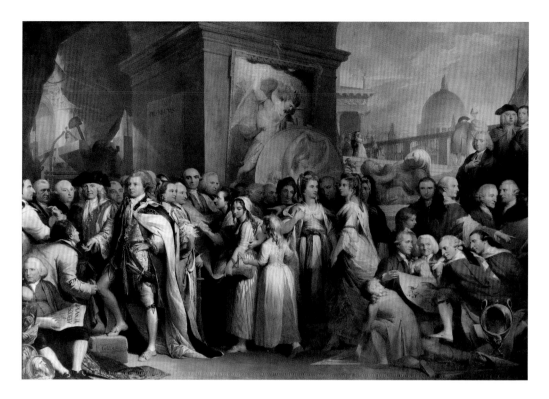

He died of pneumonia on 22 February 1806. His body was laid for a night in the Great Room of the Royal Society of Arts before being transported to St Paul's on 4 March. Reverend Fly, the cathedral's senior minor canon, conducted the funeral service in St Dunstan's Chapel before the artist was interred in the crypt, next to Reynolds. The ledger marking his grave is inscribed with a Chi-Rho, Alpha and Omega and the legend 'The GREAT HISTORICAL PAINTER JAMES BARRY'.

*The Distribution of Premiums by The Society of Arts, 1774–84, detail (Royal Society of Arts)*

# JOHN OPIE
## 1761–1807

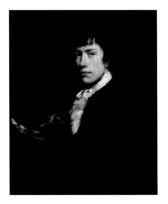

JOHN Opie's humble origins were exploited by his promoter/manager, Dr John Wolcot, who masterminded his presentation as 'The Cornish Wonder', an untaught natural genius from the provinces. Breaking into the London art world, he excelled at history and portrait painting.

The son of a Cornish carpenter, Opie was sought out in his early teens by Wolcot, who bought him out of an apprenticeship and schooled him before the pair moved to London to seek their fortune. The artist immediately attracted many sitters and was presented to George III, who bought two of his paintings. After his initial success waned, Opie turned to history painting. Closely following the example of Benjamin West, he chose Scottish subjects and paid close attention to historical detail. These works helped with his election to associate membership of the Royal Academy and full Academician status a year later. A dazzled Joshua Reynolds described him as 'like Caravaggio, but finer'. Opie would go on to be Keeper of the Royal Academy and Professor of Painting.

Taking advantage of the market for portraiture, he painted many of the leading figures of his day. Opie met several brilliant women in the political and literary Godwin circle, including the ground breaking feminist Mary Wollstonecraft, whom he painted twice, first in 1791–2 and again in 1797, when she was pregnant with the future Mary Shelley. His portraits show the influence of Rembrandt, whom he admired, having seen his works in British collections and on a tour of the Netherlands in 1786.

After a short illness Opie died on 9 April 1807. The funeral was held on 20 April and he was interred in the same vault as Reynolds. Reportedly the undertaker apologised to Robert Alderson (cousin of the artist's wife) for putting the coffin with Opie's feet towards the west rather than the east. 'Shall we change it?' he asked. 'Oh, Lord, no!' replied Alderson. 'Leave him alone! If I meet him in the next world walking about on his head, I shall know him.'

*Self Portrait*, 1785 (National Portrait Gallery)

Grave ledger by an unknown artist

*Portrait of Mary Wollstonecraft*, about 1797 (National Portrait Gallery)

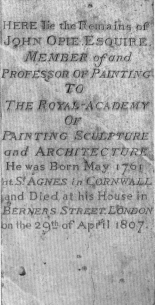

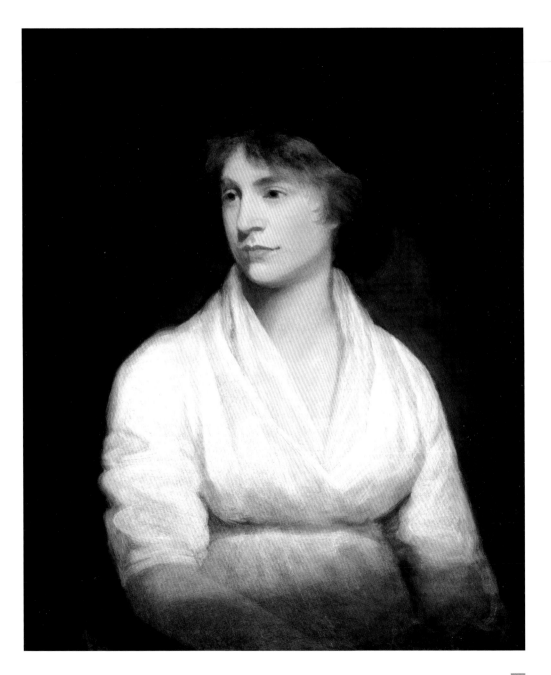

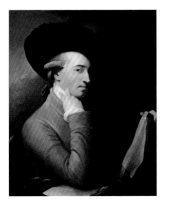

THE remarkable success of the American artist Benjamin West placed him at the forefront of history painting in Britain and revived a national interest in the genre. His abilities, astute choice of subjects and close friendship with George III gained him access to the London art world and he commanded unprecedented prices.

Born and trained in Pennsylvania, he departed for Italy in 1760 armed with prodigious self-belief. In Rome he met a number of expatriate artists and connoisseurs enthused by the art and culture of antiquity, and he set to work copying sculptures in Rome and Old Masters in northern Italy. In Venice he met Richard Dalton, Librarian to George III, who commissioned a painting from him. This led to a long and significant relationship with the King. Dalton and other English friends encouraged West to visit England, where he was immediately well received and pronounced 'the American Raphael'.

*Self Portrait*, about 1776 (Baltimore Museum of Art)

Grave ledger by an unknown artist

The painting that made his reputation, *The Death of General Wolfe*, was a trailblazing combination of realism and neoclassical composition, portraying a subject from the recent past with great accuracy of detail. More than presenting the soldier's battlefield demise in a lifelike fashion, the work staged Wolfe as a patriotic martyr and noble example. West frequently returned to this theme, which seized the national *Zeitgeist*, producing four paintings of the death of Nelson, including a monument design.

West was a founding member of the Royal Academy and in 1792 became its second President. He remained in Britain for the rest of his life and died at home in London in March 1820. King George IV agreed to award him honours similar to those bestowed on Reynolds, and the tradition of presidential burial at St Paul's commenced. The lying-in-state took place in the small exhibition room of Somerset House before a grand procession to the cathedral.

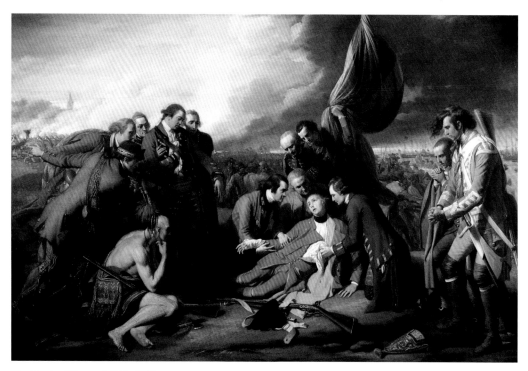

*The Death of General Wolfe*, 1770
(National Gallery of Canada, Ottawa)

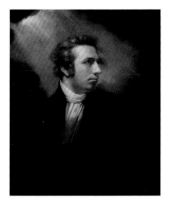

ERUDITE and intellectual, Fuseli was the foremost art historian of his generation. As an artist he became famous for his poetic subjects, which were often accompanied by an element of the supernatural.

Born Johann Heinrich Füssli in Zurich, he was encouraged to consider an ecclesiastical career and was for a short period a minister in the Zwinglian Church. His education, grounded in literature, aesthetics, Greek and Latin, inspired in him a love of Homer, Shakespeare's tragedies and Milton's *Paradise Lost*. These works, and the Bible, always remained staples in his artwork.

Portrait by James Northcote, 1778 (National Portrait Gallery)

Grave ledger by an unknown artist

Fuseli was brought to England in 1764 by Andrew Mitchell, British envoy to the Prussian court, in order to promote German literature. He initially supported himself in London through journalism, book illustration and translation; however, in 1768 he met Joshua Reynolds, who encouraged him to become a painter and study for that purpose in Italy.

On his return to England he established a reputation for himself, exhibiting history paintings and works with sensational, at times bizarre, subjects. His most famous work, *The Nightmare*, is from this period of determined self-promotion. A mysterious gothic masterpiece, it depicts a woman, supine in physical abandon, a homunculus with the caricatured face of Fuseli squatting on her while a swivel-eyed horse looks on. The painting took London by storm and was widely disseminated in print form. The original hung for some time in the home of publisher/bookseller Joseph Johnson in St Paul's Cathedral Churchyard, where Fuseli lodged.

Fuseli enjoyed good health throughout his life and died with a half-finished painting still on his easel. Honouring his role as Professor of Painting at the Royal Academy from 1799, a selection of his paintings was arrayed around the walls of the room in Somerset House where his body lay before his funeral procession to St Paul's on 25 April 1825.

IN MEMORY of HENRY FUSELI Esq. M.A ROYAL ACADEMICIAN KEEPER and PROFESSOR in PAINTING of the ROYAL ACADEMY of ARTS in LONDON This eminent Historical Painter was born at Zurich in Switzerland the 7th February 1741 and died at Putney Hill near London the 16th April 1826.

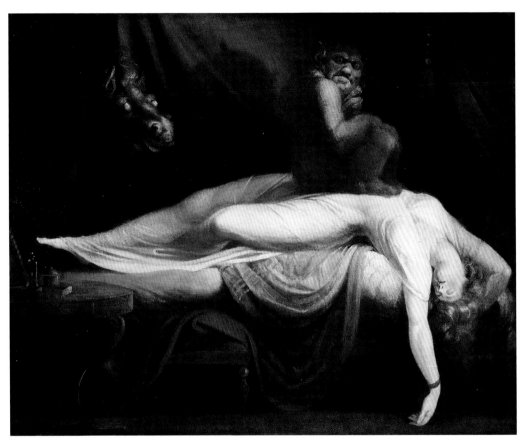

*The Nightmare*, 1781 (Detroit Institute of Arts)

# WILLIAM BLAKE
## 1757–1827

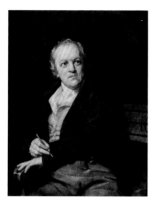

BLAKE was a visionary, engraver, painter and poet. His artistic output fused his social concern and religion with a unique aesthetic style, producing 'illuminated books' (which combined images and text), watercolours, book illustrations and paintings. His current fame stands in contrast to his obscurity in his own lifetime.

Born in London, his early promise at drawing school was followed by an apprenticeship with the printmaker James Basire. He quickly learned engraving skills, in which he would excel and innovate, and he went on to study at the Royal Academy to train as an artist and extend his range. His living was often financially precarious; however, he enjoyed the support and encouragement of dedicated friends, patrons and his wife, Catherine.

Blake's politics and belief in personal, creative and spiritual liberty were reflected in his art and poetry. His *Song of Liberty* (1792) called for the revolutionary overthrow of religious and secular tyranny. His illustrated poem 'Holy Thursday' from *Songs of Innocence* (1789) describes an annual ceremony, historically held at St Paul's Cathedral, for Charity Children of the City. The companion poem in *Songs of Experience* (1794) presents the same event as a blight that highlighted the want and poverty existing alongside wealth and plenty.

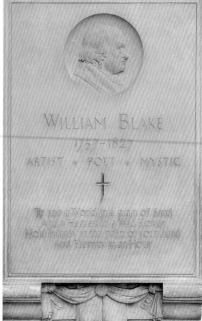

Blake died on 12 August 1827 and was buried in Bunhill Fields, Islington, traditionally a cemetery for dissenters. Having died in poverty and with little recognition, it was many years before his reputation as an artist was championed. In 1926 *The Times* printed a letter signed by the Prime Minister, the Dean of St Paul's and others, soliciting subscriptions for a centenary memorial. The resulting plaque was unveiled on 7 July 1927 by the Earl of Crawford and Balcarres.

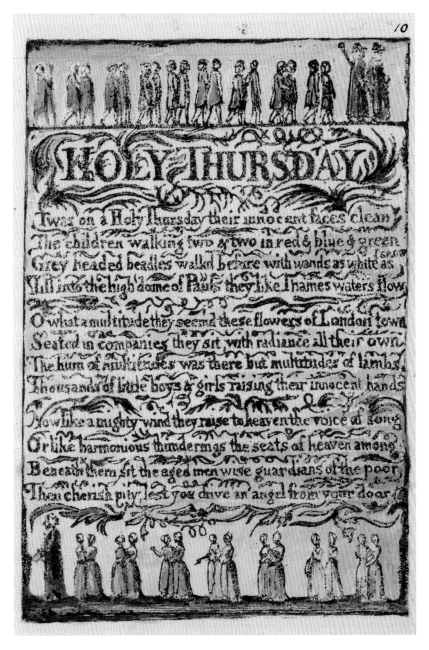

Left: Carved memorial plaque by Henry Poole, marble, 1927, with the opening lines from Blake's poem 'Auguries of Innocence':

*To see a World in a Grain of Sand*

*And a Heaven in a Wild Flower*

*Hold Infinity in the palm of your hand*

*And Eternity in an hour.*

Right: 'Holy Thursday', plate 38 from *Songs of Innocence and of Experience*, 1789–94 (Yale Center for British Art, Paul Mellon Collection)

# GEORGE DAWE

1781–1829

DAWE is best known in Russia, where he attained the position of First Painter to his Imperial Majesty the Emperor of all the Russias. His prolific production of oil portraits brought him significant wealth.

The son of a successful mezzotint engraver, Dawe published his own prints from the age of 14. His earliest oils were history paintings and drew their subjects from the Old Testament, Shakespeare's plays, Greek myth and Scottish legend. He quickly achieved associateship of the Royal Academy, becoming a full Academician in 1814, and his reputation grew steadily with the exhibition of his works at the Academy and the British Institution.

*Self Portrait,*
about 1810–29
(Te Papa Tongawera Museum of New Zealand, Wellington)

Grave ledger by an unknown artist

He made his fortune through portraiture, acquiring acclaim for likenesses of Princess Charlotte and Prince Leopold before he was talent-spotted by the Russian Emperor Alexander I. Dawe was invited to St Petersburg for the task of populating the military gallery of the Winter Palace. He obliged and, with the assistance of Russian artists, produced over three hundred portraits for the gallery, a pantheon of high-collared and richly decorated generals who had distinguished themselves in the Napoleonic Wars. Mikhail Kutuzov was a Field Marshall who played a leading role in the ejection of Napoleon's forces from Russia, for which he was awarded a victory title.

After contracting a respiratory illness, Dawe returned to London and died on 15 October 1829. He was buried with honours in St Paul's Cathedral 12 days later. A long cortège of artists and literary men formed his funeral procession from Kentish Town; the Russian Ambassador, J.M.W. Turner and Sir Thomas Lawrence were among his pall-bearers. Encountering the procession, the poet Samuel Taylor Coleridge, whose friendship with Dawes had waned owing to the artist's perceived acquisitiveness, wrote:

> *As Grub Daws pass'd beneath his Hearse's lid,*
> *On which a large RESURGAM met the eye*
> *Col. Who knew the grub cried – Lord forbid!*
> *I trust, he's only telling us a lie!*

*Mikhail Kutuzov,* 1829
(State Hermitage Museum,
St Petersburg)

# SIR THOMAS LAWRENCE
1769–1830

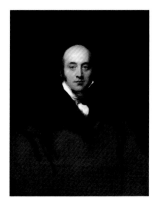

LAWRENCE became the most successful portrait painter in Britain. In the course of his illustrious career he gained a European reputation and favour at court with his astonishing virtuosity and charming manners.

Born in Bristol, Lawrence's early art education was acquired sketching customers at the Black Bear coaching inn owned by his father. When the business fell into difficulty, the precocious talent of the 10-year-old artist sustained the family through pastel portraits of the fashionable citizens of the city of Bath.

*Self Portrait*, about 1825 (Royal Academy of Arts)

Grave ledger by an unknown artist

Moving to London in 1787, Lawrence was immediately admitted to the Royal Academy Schools, where he outshone his fellow students, eliciting from Sir Joshua Reynolds the observation: 'in you Sir, the world will expect to see accomplished what I have failed to achieve'. The prophecy was borne out by Lawrence's swift rise through the ranks of the Royal Academy, his assumption, on the death of Reynolds, of the post of Painter in Ordinary to the King and, in 1820, the post of President of the Royal Academy.

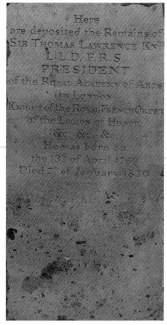

Lawrence painted almost every prominent person of the day, including actors and actresses, intellectuals, politicians, nobles and royalty. A particularly significant commission, which took him to the capital cities of Europe, was a group of portraits of the allied sovereigns, their diplomats and commanders, who shaped the Continent after the defeat of Napoleon. These include the Emperors of Austria and Prussia, the Tsar of Russia and Pope Pius VII; they are known as the 'Waterloo Chamber Series' after the room at Windsor Castle in which they are displayed.

Though he died heavily in debt, Lawrence's funeral was the grandest seen at St Paul's since that of Nelson, with numerous carriages sent by members of the nobility for the procession from Somerset House. A number of Academicians were present, including Turner, who provided written and visual records by way of homage to his friend and supporter.

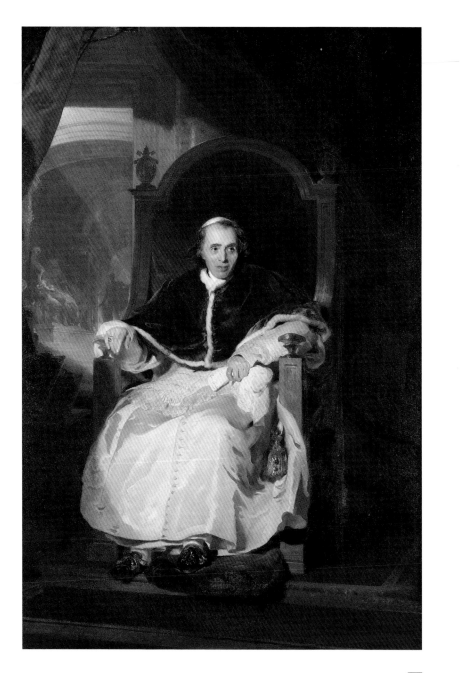

*Pope Pius VII*, 1819
(Royal Collection)

# JOHN CONSTABLE
1776–1837

PURSUING a quest to depict nature in the full range of atmosphere bestowed on it by the English weather, Constable became an important influence on the Romantic Movement in France. However, unlike Turner, born a year before him, his work failed to impress his English contemporaries and he sold relatively little of what he produced during his career.

The artist was born and raised in the Suffolk village of East Bergholt, where he developed a profound love of painting his natural surroundings. His interest in art was fostered first by his headmaster and then by the art patron Sir George Beaumont, who introduced him to the work of the French landscape painter Claude Lorraine. Once free from obligations to the family corn and coal trade, Constable moved to London, where he enrolled in the Royal Academy Schools. He made forays from the city to Hampstead Heath, where he dedicated himself to 'skying', studying the visual effects of changing meteorological conditions. The sky became the 'key note' and the chief 'organ of sentiment' in his landscape painting. He made frequent visits back to Suffolk, where he also painted directly from nature.

*Self Portrait,*
about 1799–1804
(National Portrait Gallery)

Memorial plaque
by Alfred Turner,
stone, 1937

*The Hay Wain* brings together careful observation of his native scenery with a dominating, louring sky. It failed to ignite interest at the Royal Academy but a subsequent showing in Paris made a deep impact on the painter Eugène Delacroix.

Constable died after a spell of giddiness and sickness and was buried in the churchyard of St John's, Hampstead. After his death his life's work was carefully managed by his descendants who, through exhibitions and bequests to national collections, helped to raise the status of his sketches and paintings in the public mind. A memorial was commissioned for the centenary of his death and was unveiled on 7 May 1937 by Sir William Llewellyn PRA. Today Constable is one of Britain's most famous artists.

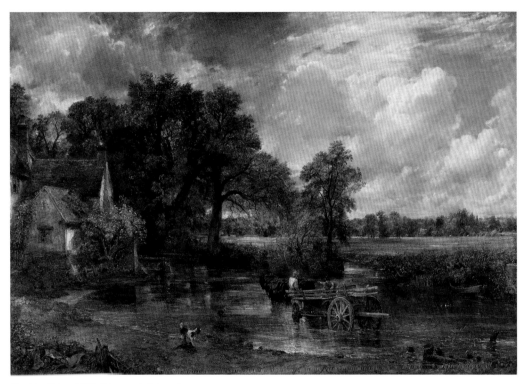

*The Hay Wain*, 1821 (National Gallery)

# JOSEPH MALLORD WILLIAM TURNER
## 1775–1851

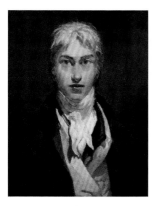

TURNER is Britain's most famous painter. His remarkable breadth of subjects include landscape, topography and seascapes; historical, literary and mythical themes; and the social, political and technological developments of his own age. He produced hundreds of sketchbooks and oil paintings and thousands of watercolours, and oversaw the engraving of many of his works. He was hailed in his own lifetime as one of the masters whose work is 'not so much of today but of all-time'.

*Self Portrait*, about 1799, detail (Tate Britain)

Grave ledger by an unknown artist

The son of a barber/wig-maker, he trained as an architect's draughtsman and practised copying from the art collection of a physician named Dr Monro. His long-standing relationship with the Royal Academy began when he entered the Schools in 1789. He exhibited there from 1790, became a full Academician in 1802, was Professor of Perspective in 1807 and in 1845, at the age of 70, served as Acting President. He also founded his own art gallery to show works on his own terms to potential clients. He was fortunate in having wealthy landed patrons who consistently commissioned paintings, and also the friendship of John Ruskin, who gave critical support, placing him at the forefront of his book *Modern Painters*.

Annual sketching tours took Turner the length and breadth of the country, where he often enjoyed the hospitality of his patrons. War restricted him to the British Isles for many years but, once able to travel, he visited the Louvre to study Old Masters and some of the most dramatic natural scenery on the Continent; later visits to Italy centred on Rome, the architecture, scenery, life and history of which would provide him with inspiration for the rest of his career.

Art, investments and property brought Turner financial independence and enabled him to keep his favourite works. *Dido Building Carthage*, one of his best-known earlier oils, was never sold. A story, told by the artist C.R. Leslie, relates that Turner asked to be buried 'rolled up' in the canvas of 'the Carthage'. Fortunately for posterity, the plan was not realised: the painting was left to the National Gallery with the request that it hang between two

JOSEPH
MALLORD WILLIAM
TURNER,
R. A.
DIED 19ᵀᴴ DECEMBER,
1851
AGED 76.

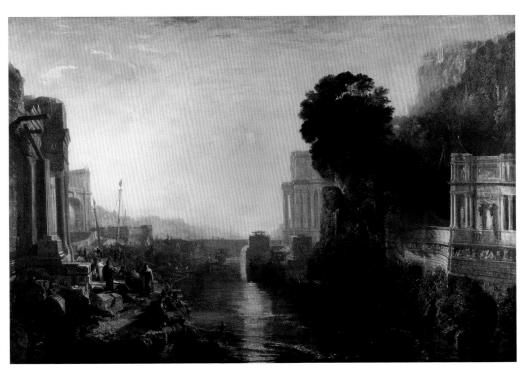

*Dido Building Carthage*, 1815 (National Gallery)

paintings by Claude Lorrain, whose art Turner greatly admired and hoped to surpass. The painting is one of a pair that meditate on the rise and fall of empire.

As a well-established and wealthy artist, Turner was free to pursue his imaginative genius as he wished. Thus his radical later paintings, *Rain, Speed and Steam* and *After the Deluge*, ascribed by some to mental or physical illness, saw abandonment of precise detail in favour of bold achievements in light and mood, prefiguring Impressionism.

Turner's later years were spent in self-imposed obscurity, living under the sobriquet Admiral Booth. He died on 19 December 1851 and was moved for his lying-in-state to the gallery he had built. His friend the architect Philip Hardwick was in charge of making the grand funeral arrangements, a ceremony at which places were insufficient to meet demand. On 30 December his remains were interred in the crypt at St Paul's, close to Reynolds and Lawrence, according to his wish 'to be buried among my Brothers in Art'. As a choirboy, the future celebrated Cathedral Organist Sir John Stainer stood beside Turner's grave as he was buried. He later recalled the open windows and puddles on the broken floor.

The moment was painted by George Jones, Keeper of the Royal Academy, who attended as friend and an executor of Turner's complicated will. As well as leaving his unsold paintings to the nation, he bequeathed a substantial £1,000 for a monument. He had resisted depiction in his lifetime and there are consequently few reliable likenesses.

Monument by Patrick MacDowell, marble, 1855

# SIR EDWIN LANDSEER
## 1802–1873

THE foremost animal painter of his day, Landseer enlivened simple representations of wild and domestic creatures by imbuing his scenes with character and narrative. His well-known sentimental and anthropomorphising images belie a complex personality.

As a child he sketched cats and dogs around his native Hampstead, while the more exotic beasts in the menageries of London also fired his imagination. His earliest-known drawing, of a dog, was made at the age of five. He made hundreds of studies of the species throughout his career, emphasising the traits of obedience and devotion, which proved popular with the public. Fascinated by Scottish wildlife, he developed a deep love for the Highland landscape and way of life. His painting of a stag, *The Monarch of the Glen*, has become internationally famous.

The Royal Academy Schools accepted him at the age of 14; he became a full Royal Academy member in 1831 and was later elected President, a role he declined on the basis of ill-health. As he rose steadily through the ranks he mixed with high society and also in more bohemian circles. In 1840, however, a series of personal setbacks initiated a breakdown. His problems were amplified by alcohol and drug consumption but he remained productive at the easel.

Landseer's funeral and burial at St Paul's on 11 October 1873 was a national event. The cortège passed the Trafalgar Square lions made by the artist between 1857 and 1867. Queen Victoria and the Prince of Wales sent a wreath of flowers with the inscription: 'A tribute of friendship and admiration for great talents'. His wall monument, installed in July 1882, features his painting *The Old Shepherd's Chief Mourner*, a collie crouching by the coffin of his master. The corbels above bear reliefs of the Trafalgar Square lions, while on the base is an eagle with a key in its beak – the Landseer family crest.

Portrait by Francis Grant, about 1852 (National Portrait Gallery)

Wall plaque by Thomas Woolner, marble, 1882

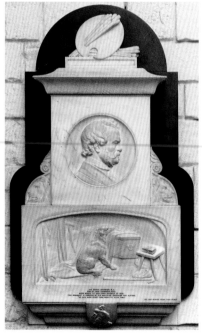

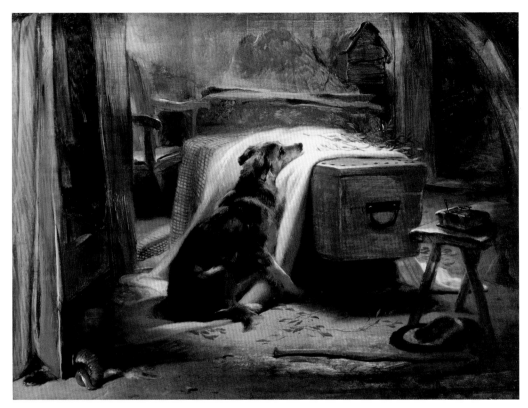

*The Old Shepherd's Chief Mourner*, 1837
(Victoria and Albert Museum)

# JOHN HENRY FOLEY
## 1818–1874

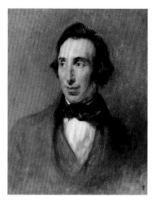

JOHN Foley became the master of public statuary in mid-Victorian Britain. The dynamism of his work, together with his technical excellence, left an enduring legacy through his many students and later admirers. He was the first sculptor admitted to Artists' Corner.

Born in Dublin, the son of a grocer, he followed his elder brother to the Royal Dublin Society's Art Schools and the Royal Academy Schools in London. He quickly established a reputation with works of classical and Shakespearean subjects in marble, such as *Ino and Bacchus* and *The Death of Lear*. Following the success of two figure sculptures for the Houses of Parliament, he was inundated with portrait commissions for both contemporary and historical figures in Britain, Ireland and abroad.

His most widely recognised work is his contribution to the Albert Memorial, unveiled in Kensington Gardens in 1872, to commemorate Prince Albert, husband of Queen Victoria. This work, in common with several monuments added to St Paul's in the same period, combines memorialisation of an individual with a celebration of British Imperialism. Foley was the only sculptor to provide two major sculptures for the Albert Memorial: a marble representation of 'Asia' and, following the death of Carlo Marochetti, the gilt-bronze figure of Albert. The Prince is depicted seated in the ceremonial dress of the Order of the Garter, carrying in his left hand the handbook of the Great Exhibition of 1851, which he had organised. Unfinished at the time of Foley's death, the sculpture was completed by his principal student, Thomas Brock.

An attack of pleurisy while working on the Albert Memorial in inclement weather weakened Foley and he died at home in Hampstead on 27 August 1874. *The Times* reported that his funeral at St Paul's, on 5 September, seemed 'silent and dreary' being without music of any kind, but it did not want for the heartfelt sorrow of many friends. A simple brass plaque marks the place of his burial in the crypt.

Portrait by Thomas Mogford (National Gallery of Ireland)

Brass plaque by an unknown artist

Prince Albert from the Albert Memorial, gilt bronze, 1872

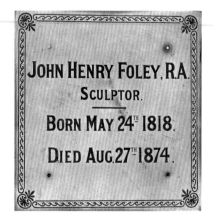

JOHN HENRY FOLEY, R.A.
SCULPTOR.
———
BORN MAY 24ᵀᴴ 1818.
DIED AUG. 27ᵀᴴ 1874.

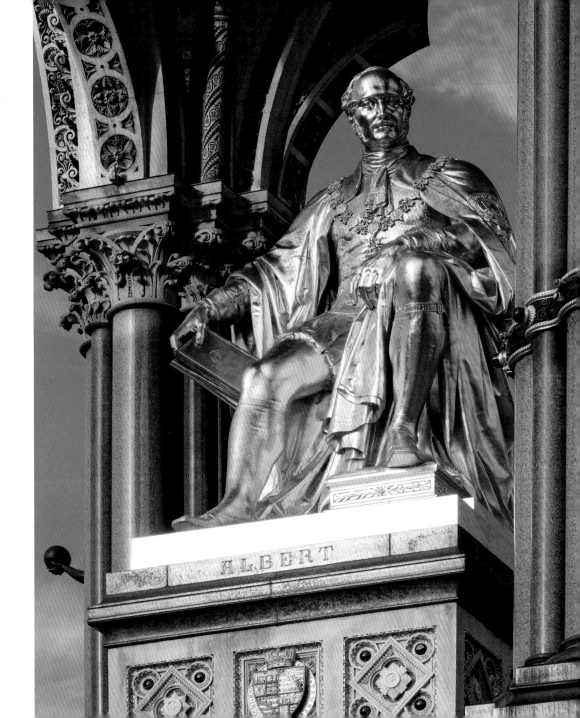

THE satire of George Cruikshank's caricatures and the originality of his illustrations propelled him to fame in his own lifetime. In an age of revolution, Europe-wide military conflict and profound domestic social change, he was never short of inspiration. In later life his work reflected fierce advocacy of temperance.

His father and brother were caricaturists and he learnt his trade at an early age, sketching competently by the age of seven and adding titles, background and dialogue to his father's etchings. He drew inspiration from his forebear William Hogarth and tested his skills in competition with satirists of the preceding generation, James Gillray and Thomas Rowlandson.

Some of Cruikshank's most successful early work set out to belittle the French Emperor, Napoleon Bonaparte. At home he lampooned the government, repressive laws, religious zealots and both ends of the political spectrum. While often inventive, his work could also pander to national and racial stereotypes. The corrupt court of the Prince Regent was a particular target and such was Cruikshank's success that in 1820 the new king, George IV, directed that he should 'be paid £100 not to caricature His Majesty in any immoral situation'.

Cruikshank succumbed to acute respiratory infection in January 1878. He was temporarily buried in Kensal Green Cemetery until the crypt of St Paul's, then under repair, could be re-opened. He was interred here on 29 November, some distance to the west of Artists' Corner. He lies beneath a substantial marble grave slab, accompanied by a wall plaque organised in 1880 by his wife, Eliza, who paid off his debts and dedicated the plaque from 'her who loved him best'. A bust by John Adams-Acton originally above the plaque, added in 1881 was removed during reordering, possibly owing to revelations concerning Cruikshank's unusual family arrangements.

Portrait by an unknown artist, 1936 (National Portrait Gallery)

Memorial plaque with bust by John Adams, marble, 1881

GEORGE CRUIKSHANK,
ARTIST,
DESIGNER, ETCHER, PAINTER.
___
BORN AT Nº.– DUKE STREET, Sᵗ GEORGE'S BLOOMSBURY, LONDON,
ON SEPTEMBER 27ᵀᴴ 1792,
DIED AT 263, HAMPSTEAD ROAD, Sᵗ PANCRAS, LONDON,
ON FEBRUARY 1ˢᵗ 1878,
AGED 86 YEARS.

IN MEMORY OF HIS GENIUS AND HIS ART,
HIS MATCHLESS INDUSTRY AND WORTHY WORK
FOR ALL HIS FELLOW MEN; THIS MONUMENT
IS HUMBLY PLACED WITHIN THIS SACRED FANE,
BY HER WHO LOVED HIM BEST, HIS WIDOWED WIFE.
Eliza Cruikshank.
Feb 9ᵗʰ 1880.

*George IV from The Queen's Matrimonial Ladder*, printed by William Hone, 1820
(S.P. Lohia Collection)

CALDECOTT was an artist and illustrator best known for his picture books for children. In a short but productive career he also produced artwork for books and journals for adults; his work was admired by Vincent Van Gogh and Paul Gauguin.

*Self Portrait*, 1884 (Aberdeen Art Gallery and Museums)

Monument by Alfred Gilbert, aluminium and marble, 1909

Born in Chester, he showed an early talent for drawing, modelling and carving but was encouraged to go into banking. Although he did well in the profession, he grew discontented and began formal training at evening classes at Manchester School of Art. He went on to submit illustrations to London publishers, including Henry Blackburn, who became his life-long friend, collaborator and biographer. Their travels in Europe generated a number of books, including *Breton Folk: An Artistic Tour in Brittany* (1880).

After initial success illustrating Washington Irving's *Old Christmas* (1876), Caldecott embarked on his picture books, beginning with *The Diverting History of John Gilpin* (1878), a playfully illustrated poem written nearly a hundred years earlier by the poet William Cowper. Caldecott's images drew on his close observation of animal forms and behaviour, together with other details from everyday rural life. The publication demonstrated a unity of design that made this, and his subsequent 15 picture books, so engaging. His excellence and influence in children's book illustration is still recognised with the Caldecott Medal, awarded for the 'most distinguished American picture book for children'.

Caldecott frequently travelled abroad and in 1885 he made his way to the United States, where, weakened by

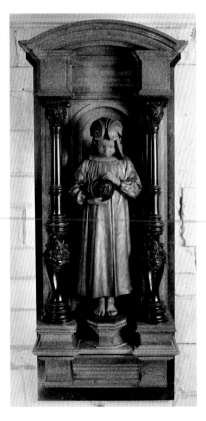

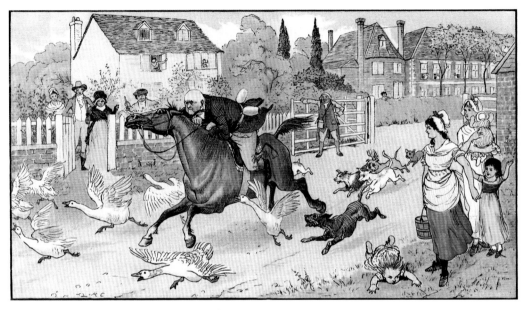

Illustration from *The Diverting History of John Gilpin*, 1878
(The Cowper Newton Museum)

a difficult Atlantic crossing, he died in February 1886. He was buried in
St Augustine, Florida. In London his friends contributed to a memorial,
commissioned from the celebrated sculptor Albert Gilbert, and the resulting
monument, a life-sized child in Breton dress, was unveiled in St Paul's in 1900.
The child holds a medallion with a profile portrait of Caldecott and wears
an unusual headdress, possibly a stylised Breton mourning hood. The artist's
younger brother Revd Alfred Caldecott, a Prebendary of St Paul's from 1915
to 1935, presided over the ceremony.

# FRANCIS MONTAGUE 'FRANK' HOLL
## 1845–1888

FAMOUS in his own lifetime for melancholic paintings that drew attention to the plight of the poor, the intimacy of Holl's work elicited the admiration of Queen Victoria. In later life he became overwhelmed by his workload, which damaged his fragile health.

Born into an artistic family in London, his father, uncle and grandfather were engravers and he learned drawing at home from an early age. At 15 he was accepted to the Royal Academy Schools, where he won a gold medal in 1863.

His early works took inspiration from biblical quotes, which he applied to scenes of Victorian life. One such work, *The Lord Gave and the Lord Taketh Away*, painted in 1869, depicts a bereaved family, grief-stricken and praying together. A meditation on the theme of faith in the face of tragedy, a subject to which he would often return, the work received considerable critical and public acclaim. It won Holl a travelling scholarship to Continental Europe and in 1870 similar works were commissioned by Queen Victoria.

From the early 1880s Holl focused on portraiture and increased his output, exhibiting more paintings than ever before in the Royal Academy shows. He received three sitters a day and took on work from other artists who were too busy. The results were sombre but striking likenesses of men such as Prime Minister William Gladstone and American financier John Pierpont Morgan. They reveal the influence of his heroes, Diego Velázquez and Rembrandt van Rijn.

Holl died on 31 July 1888 and was buried in Highgate Cemetery. A memorial fund was set up with the intention of buying a major work for the national collection and building a monument in St Paul's. After six months £600 had been collected, which was put towards his memorial. Originally located next to the Caldecott memorial, the portrait bust sported a now absent aluminium beret.

*Self Portrait*, 1863 (National Portrait Gallery)

Monument by Joseph Edgar Boehm and Alfred Gilbert, marble and bronze, 1893

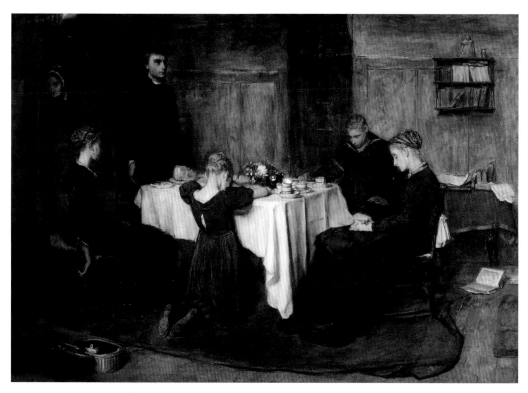

*The Lord Gave and the Lord Taketh Away*, 1869
(Guildhall Art Gallery)

# SIR JOSEPH EDGAR BOEHM

## 1834–1890

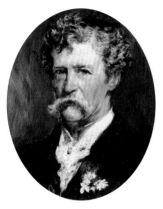

A HIGHLY influential sculptor in his day, Boehm created many well-known statues around London and several works for St Paul's. Born in Vienna to Hungarian parents, the artist initially worked in terracotta and bronze, producing medals, busts, statuettes and hunting scenes. As his career progressed his works grew larger, with many prestigious monumental statues and funerary monuments produced in his later life.

Much of his early artistic education was acquired from his father, Director of the Vienna mint and an avid art collector. Boehm (junior) travelled widely in Europe and was profoundly influenced by the sculpture of the Italian Renaissance. Following success in the International exhibition of 1862, he settled in England and took British nationality three years later. His membership of the Royal Academy was initially resisted but eventually he became a full member in 1881 and by the mid-1880s he was an influential voice in the institution.

Boehm was partly or wholly responsible for five monuments in St Paul's Cathedral: an effigy for the sarcophagus of General Gordon; a bust of Richard Southwell Bourke, Earl of Mayo; a memorial portrait in low relief of Major General Sir Herbert Stewart; a bust of his friend the artist Francis Montagu Holl; and a profile portrait of the Australian statesman William Bede Dalley. The Gordon effigy was one of his most prestigious commissions. A plaster cast of the effigy and sarcophagus were made and placed in location in May 1886. *The Times* found the work 'remarkable not only for artistic merit but for its extraordinary resemblance'.

Sculptor in Ordinary to Queen Victoria from 1880, Boehm became a teacher and close friend to her daughter Princess Louise. The Princess was visiting his home to view his busts when he died suddenly in December 1890. He was given an impressive funeral beneath the dome of St Paul's at the request of the Queen.

Portrait by John Pettie, 1883 (Aberdeen Art Gallery and Museums)

Memorial brass made by Elkington & Co.

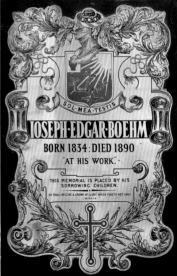

SOL·MEA·TESTIS

JOSEPH·EDGAR·BOEHM

BORN 1834 : DIED 1890

"AT HIS WORK."

THIS MEMORIAL IS PLACED BY HIS SORROWING CHILDREN.

HE SHALL RECEIVE A CROWN OF GLORY WHICH FADETH NOT AWAY
I PETER V.4

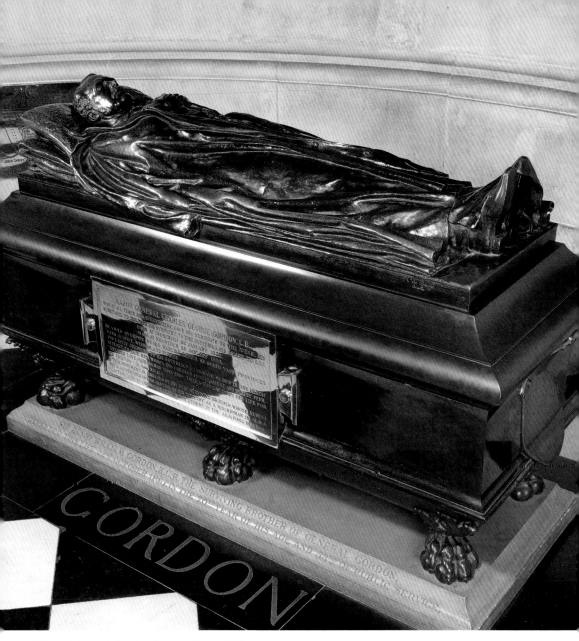

Effigy of General Gordon, bronze, about 1885

# SIR FREDERIC LEIGHTON
## 1830–1896

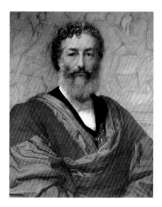

AFTER an initial struggle to impress the London art establishment, Frederic Leighton rose to be one of the most respected and influential figures in the late Victorian London art world, with a trove of international honours.

He was born into a financially independent medical family and spent his youth living and travelling in Europe, where he received art training from the German artist Edward von Steinle and absorbed the influence of the art of the Renaissance. At the age of 20 he exhibited his first large-scale painting,

*Self Portrait*, 1880 (Uffizi Gallery, Florence)

Monument by Thomas Brock, marble and bronze, 1902, and ledger by Richard Norman Shaw, brass, 1896

*Cimabue's celebrated Madonna is carried in Procession through the Streets of Florence*, at the Royal Academy. An immediate success, the painting was purchased by Queen Victoria.

Leighton's peripatetic lifestyle ended with a move to London in 1859 and the construction of a house and studio in Kensington in 1864. The art establishment proved suspicious of his Continental background, but he steadily built a reputation with his paintings of biblical, historical and classical subjects. Processions particularly lent themselves to his theatrical staging and love of flowing drapery. He also painted landscapes and a few portraits, and produced a small number of lithe sculptures in collaboration with his assistant Thomas Brock. This output, together with his indefatigable championing of the arts, saw him ascend through the ranks of the Royal Academy to be elected President. He was knighted in 1878 and the first painter to receive a peerage, in 1896.

FREDERIC
1ST BARON LEIGHTON OF STRETTON
7TH PRESIDENT OF THE ROYAL ACADEMY.
BORN·DECEMBER·3·1830.
DIED·JANUARY·25·1896.

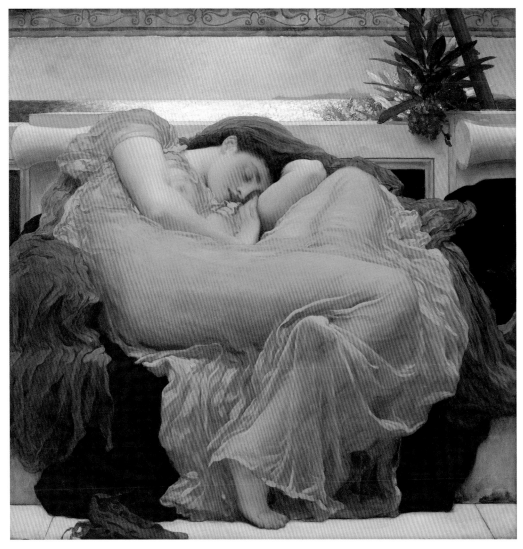

*Flaming June*, 1895 (Museo de Arte de Ponce, Ponce, Puerto Rico)

At St Paul's he encouraged the creation of the monument to the Duke of Wellington and paid for it to be moved into its current position. The most prominent of Leighton's works on public display, had the project come to completion, would have been a design for decorating the interior of the cathedral dome with a subject from the book of Revelation: 'And the Sea gave up the Dead which were in it'. The proposal was exhibited at the Royal Academy in 1882 but was rejected by the Cathedral Chapter. Leighton's best-known work, *Flaming June*, was similarly a meditation on the cycles of existence, popularised nationally by prints made available by the *The Graphic* magazine. The painting is now in Puerto Rico.

Leighton died of heart disease at his home in early 1896. His body was taken to the Octagon Room at the Royal Academy, from where, on 3 February, it was brought to St Paul's for his funeral and burial. The hearse processed through crowds accompanied by a detachment of the Artists' Rifle Volunteer Corps (in which Leighton had been a colonel). Among those in the packed cathedral were representatives of the Royal Family, the German Emperor and the King of Belgium, members of both Houses of Parliament and delegates from learned bodies, artistic associations and the art committees of various provincial municipalities.

The Prince of Wales, later King Edward VII, who had been a friend and supporter of Leighton, headed the committee for promoting a memorial to the artist and personally contributed funds to its production. The monument in a bay of the north nave aisle was made by Thomas Brock and features a recumbent bronze statue of Leighton on a pedestal of Greek cipollino marble with bronze plaques. At the head a figure symbolises Painting, and at the feet another represents Sculpture, the latter holding a reduced version of Leighton's sculpture *The Sluggard*. The monument was unveiled by Leighton's collaborator and successor to the presidency of the Royal Academy, Edward Poynter, on 19 February 1902 in front of a company of fellow artists as well as the cathedral clergy. The elaborate floor ledger was commissioned by the Royal Academy.

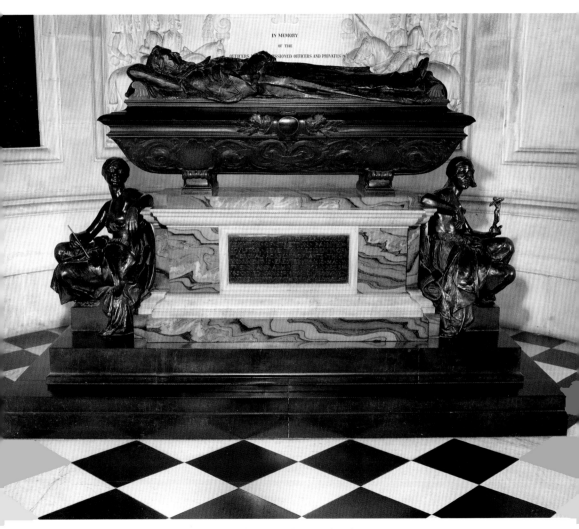

Monument by Thomas Brock, bronze figures, Greek cipollino pedestal
and marble base, 1902

# GEORGE RICHMOND
## 1809–1896

THE pre-eminent portraitist of his generation, Richmond was adept in pencil and ink, crayon, chalk, watercolour and oils. He also made some notable sculptures and participated in the restoration of historical paintings.

Born into an artistic family, Richmond demonstrated his drawing abilities at an early age and enrolled at the Royal Academy Schools in 1824. He subsequently studied abroad, first in Paris, then Italy in later life. The most profound influence on his early art and life was William Blake, who gathered a group of young artists, 'the Ancients', around him. The group, including Richmond's life-long friend Samuel Palmer, met regularly in Shoreham, Kent, to paint and discuss their work.

After a romantic elopement to Scotland with Julia, the sister of a friend, a long and happy marriage produced 15 children and 40 grandchildren. The financial pressures associated with this extended family, however, required a focus on profitable portraiture over his preference for landscape painting. An engraving of his portrait of William Wilberforce, Member of Parliament and anti-slavery campaigner, proved highly popular and boosted his reputation. Many sitters from the gentry, clergy and nobility followed. His portrait of Charlotte Brontë, commissioned by her publisher, is one of a number of Richmond's portraits of leading female intellectuals and reformers.

He died at home in London on 19 March 1896 and was buried in Highgate Cemetery. A memorial plaque, commissioned by his sons and daughters, was unveiled on 15 December 1897. Richmond was already well connected to St Paul's: he had been commissioned to sculpt an effigy of Charles Blomfield, Bishop of London, for the cathedral and was asked to be a member of the first committee for the decoration of St Paul's. Many years later his son, W.B. Richmond, would 'complete' the decoration, designing the mosaic scheme for the quire.

*Self Portrait*, 1840 (Fitzwilliam Museum, Cambridge)

Mural tablet by W.B. Richmond and John Richmond, marble and bronze, 1897

*Charlotte Brontë*, 1850 (National Portrait Gallery)

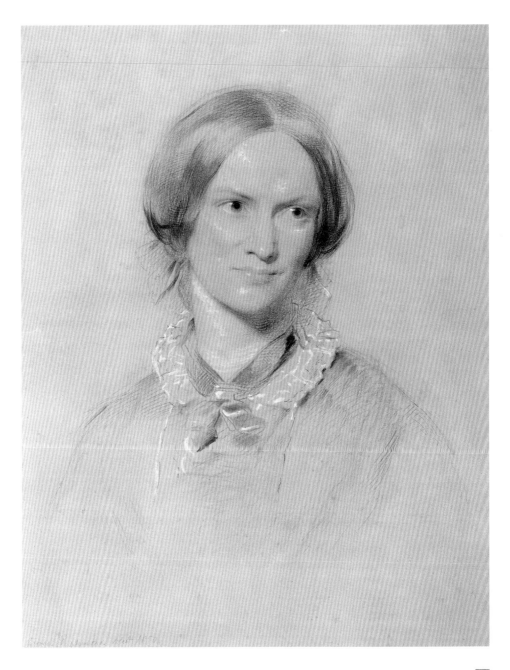

# SIR JOHN EVERETT MILLAIS

1829–1896

MANY of the painters in Artists' Corner showed prodigious talent from an early age but none more so than John Millais. The youngest student ever admitted to the Royal Academy Schools, his mastery enabled him to test the boundaries of accepted taste and he was central to the birth of the radical artist group the Pre-Raphaelites.

Portrait by G.F. Watts 1871 (National Portrait Gallery)

Memorial ledger by Richard Norman Shaw RA, brass and black marble, 1899

Following a childhood on the island of Jersey, his parents moved Millais to London to train as a professional artist. In 1840, aged 11, he was admitted to the Royal Academy Schools, where he would later form a close friendship with William Holman Hunt. The pair shared views about the state of British art and, rejecting the Academy's emphasis on classicism, resolved to paint people and things just as they found them. Taking inspiration from the art which had preceded the time of Raphael (1483–1520), they and five colleagues decided in 1848 to call themselves the Pre-Raphaelite Brotherhood.

Millais applied Pre-Raphaelite principles to portraits of his contemporaries as well as to historical and literary scenes. In summer 1851 he began *Ophelia*, his masterpiece of outdoor Pre-Raphaelite painting, which depicts the death of the heroine of William Shakespeare's *Hamlet*, described in Act 1, Scene 7. 'Her clothes spread wide, And mermaid-like a while they bore her up'.

Despite his youthful rebellion, Millais remained devoted to the Royal Academy, where he learned, taught, served on the Hanging Committee and exhibited his own work. He reluctantly accepted the presidency, as he was seriously ill from throat cancer, and only six months later, on 13 August 1896, Millais died at home. His funeral at St Paul's took place on 20 August, with representatives of the Royal Family and international ambassadors in attendance and Holman Hunt acting as a pall-bearer. His floor ledger was commissioned by the Royal Academy; however, a campaign for a statue, led by the Prince of Wales, foundered because there was insufficient space on the cathedral floor.

SIR JOHN EVERETT MILLAIS BART 8th President of the ROYAL ACADEMY BORN JUNE 8 1829 DIED AUGUST 13 1896.

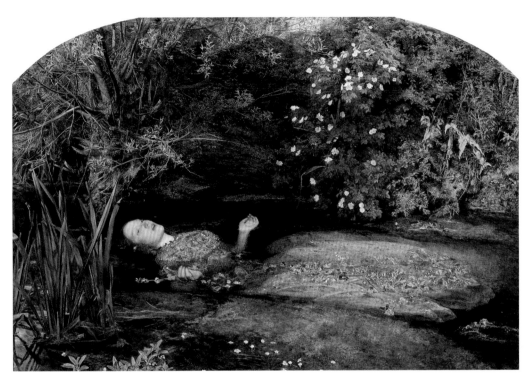

*Ophelia*, 1851–2 (Tate Britain)

# WILLIAM HOLMAN HUNT
## 1827–1910

HUNT painted the most famous religious image of the nineteenth-century, *The Light of the World*. As one of the founding members of the Pre-Raphaelite Brotherhood, he applied their emulation of the art of late medieval and early Renaissance Europe to biblical scenes, portraits and literary subjects.

Born at Love Lane, a short walk from St Paul's, he rejected the attempts of his father, a warehouseman, to induct him into his own trade. Instead, Hunt found a post for himself as a copying clerk. He copied works in the National Gallery and, while studying at the British Museum, met John Millais, who was to become his closest friend. Never accepted as an Associate of the Royal Academy, he avoided exhibiting there in later life.

*Self Portrait*, 1867 (Uffizi Gallery, Florence)

Grave ledger by Eric Gill, black marble, 1911

St Paul's is home to the third version of the *The Light of the World*. The first, made in 1853, is in Keble College, Oxford, the second, painted shortly afterwards, can be seen in the Manchester Art Gallery. The St Paul's canvas was begun around 1900 as a protest against the treatment of the original, which visitors had to pay to see. The painting takes its title from the Gospel of St John: 'I am the Light of the World; he who follows me will not walk in darkness, but will have the Light of Life'. The painting shows Christ knocking on a door overgrown with brambles, a symbol of the human heart that cannot be opened from the outside. Purchased from Hunt by the industrialist Charles Booth following a tour of British Colonies, it was unveiled in the south nave aisle at a service in June 1908.

In 1905 Hunt was awarded the Order of Merit, which may have inspired him to seek a coat of arms, granted in the same year. The accompanying motto 'From truth unswerving', appears on his grave ledger. He died of bronchitis in 1910 and his ashes were brought to St Paul's (the first interment of ashes in the cathedral). His funeral, on 12 September, was attended by thousands inside the cathedral and crowds gathered in the churchyard outside.

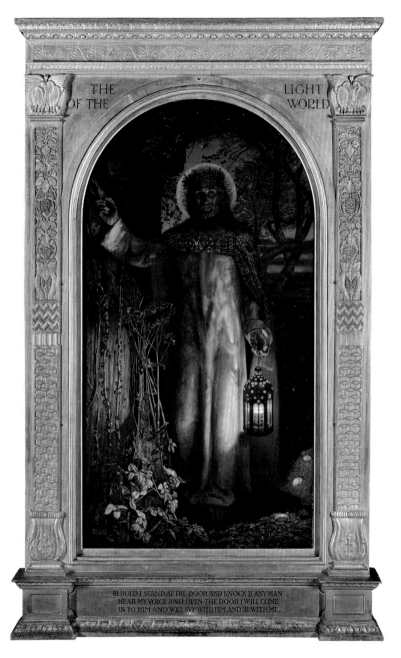

*The Light of the World*, 1904

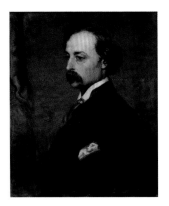

ORCHARDSON rose to prominence with his melodramatic scenes from history and Scottish and English literature. He mastered portraiture and scenes of contemporary social awkwardness, often featuring an individual physically and psychologically distanced from a group. It was a painting of the French Emperor Napoleon that brought him widespread popularity.

Portrait by Henry Weigall, 1878–81 (National Portrait Gallery)

The name Quiller Orchardson combined those of the artist's Austrian mother and Scottish father. His formal training began at the age of 13 in Edinburgh, his native city. This grounding prepared him for a career as an outstanding narrative painter. After exhibiting subjects from Shakespeare, Dickens and Walter Scott at the Scottish Royal Academy, he moved to London in 1862. His painting *The Queen of the Swords*, inspired by a description of a Shetland sword dance in Walter Scott's novel *The Pirate*, ensured his election as Royal Academician in 1877.

Memorial plaque by Sir William Reynolds-Stephens, marble, alabaster, bronze and brass, 1913

*Napoleon on board the Bellerophon* was exhibited at the Royal Academy in 1880. Six weeks after defeat at the Battle of Waterloo in 1815, Napoleon, trapped in Rochefort, surrendered to the captain of HMS *Bellerophon* blockading the port. The ship carried him to Plymouth, where his exile to the island of St Helena was decided. The painting depicts the morning of 23 July 1821, as Napoleon watches the French shoreline recede for the last time, while his retinue of French officers looks on.

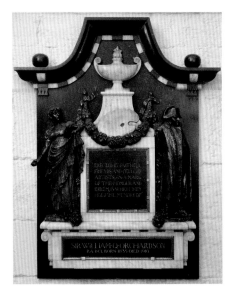

The artist died of heart disease at his home on 13 April 1910. Over a hundred people responded to a proposal for a monument, many of them RAs and ARAs. The sculptor chosen for the commission, Sir William Reynolds-Stephens, frequently experimented with different metals and combined various materials in the same work. His design features a funerary urn, a garland, the figure of Napoleon from Orchardson's *Bellepheron* painting and his *Farmer's Daughter* painted the following year.

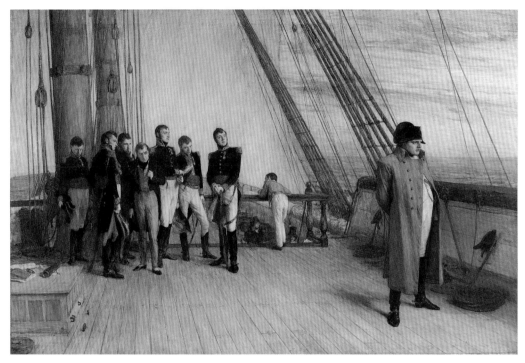

*Napoleon on Board the Bellerophon*, about 1880
(Tate)

# EDWIN AUSTIN ABBEY
## 1852–1911

AN American muralist, illustrator and painter, Abbey trained in Philadelphia and became well known for his drawings and paintings of Shakespearean and historical scenes. He travelled to England for a work assignment in 1878 and, having become friends with many leading artists and writers in the capital, settled permanently in 1883 – he had, according to his biographer E.V. Lucas, 'a golden nature warming like sunshine everyone who came near him'.

Abbey became a member of the Royal Academy in 1898 and soon after received one of his best-known commissions, the only official picture of the coronation of Edward VII. He attended the ceremony at Westminster Abbey and made sketches from a box built close to the centre of events. Abbey noted that proceedings were frequently imperilled by the extreme age of some of the officiating clergy and he found the work challenging, not least because 'the principal personages insisted upon standing in front of each other and spoiling the grand effect, which was really magnificent'.

Other significant works by Abbey include mural cycles for Boston Public Library, the Pennsylvanian State Capitol, the Royal Exchange in London and the Peers' Corridor in the House of Lords.

He died after a short illness and his ashes were interred in the churchyard of Old St Andrews Church in Kingsbury, north-west London. Five years later, in the midst of the First World War, a memorial tablet was unveiled in the crypt of St Paul's by Princess Louise. Addresses were given by Edward Poynter and Dr Page, the American Ambassador. Dr Page emphasised 'that part of the artist's life which was spent instructing the New World in the charms of the old'. Gertrude Abbey would later oversee her husband's wish for a memorial fund to support mural painting in Great Britain.

Portrait by George Frederick Watts, 1898 (Yale University Art Gallery)

Memorial by Frank Dicksee and Alfred Parsons, bronze and marble, 1916

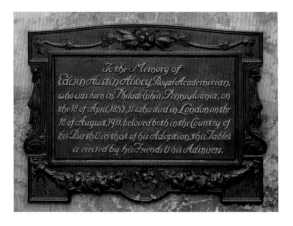

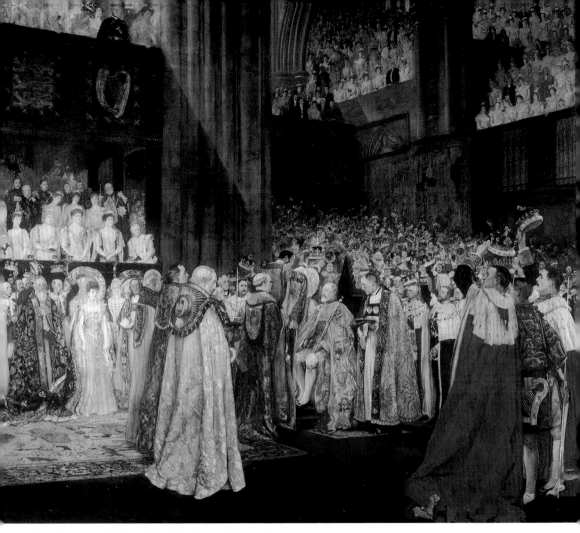

*The Coronation of Edward VII*, 1902–7, detail (Royal Collection)

# SIR LAWRENCE ALMA-TADEMA
## 1836–1912

ALMA-TADEMA combined his enthusiasms for painting and archaeology to specialise in sun-kissed scenes of everyday life in ancient Greece and Italy. His precisely reconstructed historical oil paintings depicting social situations, often with a comical or ironic twist, made him internationally famous.

Born in Dronryp in Friesland, he painted from an early age before training at the Art Academy of Antwerp and serving as assistant to the history painters Louis De Taeye and Henri Leys. Under their influence he produced scenes from the early medieval history of Northern Europe until his honeymoon to Pompeii in 1863, where he was inspired by first-hand study of Roman art and architecture. A meeting with the French artist Jean-Léon Gérôme soon after reinforced his commitment to ancient subjects.

He moved to London in 1870, following the death of his first wife, and established himself with a purpose-built studio house and musical soirées attended by high society. Remaining Dutch, he received denization from Queen Victoria in 1873, became an ARA in 1876 and an RA in 1879. His painting *The Roses of Heliogabalus*, exhibited at the Royal Academy in 1888 and at his memorial exhibition in 1913, reflects his interest in inglorious episodes and increasingly ambitious compositions. Such works fell dramatically out of favour immediately after his death, however they provided ongoing inspiration for set designers working on Hollywood epics.

After Alma-Tadema's death in Wiesbaden on 25 June 1912, a committee of his friends and admirers was formed at the Royal Academy. It was chaired by Edward Poynter and undertook to provide an inscribed slab in St Paul's Cathedral. Not everyone shared the committee's enthusiasm for the artist: the cathedral archives record some initial reluctance towards Alma-Tadema's interment. However, the Dean relented and the funeral service was held in St Paul's at noon on 5 July.

*Self Portrait*, 1896
(Uffizi Gallery, Florence)

Memorial by Sir Reginald Blomfeld, brass and black marble, 1916

SIR
LAWRENCE
ALMA-TADEMA
O·M ✠ R·A
·BORN·IAN·VIII·
MDCCCXXXVI
·DIED·IVNE·XXV·
·MDCCCCXII·

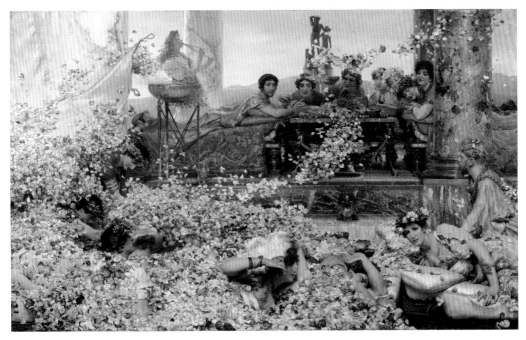

*The Roses of Heliogabalus*, 1888 (private collection)

# SIR EDWARD POYNTER
## 1836–1919

A LEADING figure of the English classical revival, Poynter coupled his archaeological knowledge with abundant use of the nude in spectacular orientalist fantasies. A true polymath, he produced history paintings in oil and watercolour, portraits and significant decorative art, and he was an accomplished educator, administrator and museum official.

Born in to an artistic family, he began art training in 1852 under Thomas Shotter Boys, the watercolourist friend of his father. The following year he wintered in Rome. Here he met Frederic Leighton, who increased his enthusiasm for art, informed his style and became a close friend (they would later collaborate on a proposal for decorating the dome of St Paul's). Back in England, Poynter found the Royal Academy Schools inadequate and moved to Paris in 1855, where, in the studio of Charles Gleyre, he absorbed the influence of Ingres and the French classicists.

Poynter's love of historical detail is reflected in his involvement, together with Holman Hunt and Alma-Tadema, in the Society for the Preservation of the Monuments of Ancient Egypt. His knowledge informed works such as his *Israel in Egypt*, which depicts Israelite slaves dragging a monumental lion for the adornment of a temple, based on Exodus 1: 7–11. This painting, exhibited at the Royal Academy in 1867, helped to establish his reputation and gain his election as an ARA.

Meanwhile, his career as a decorative artist also flourished. Indeed, as a significant figure in the 'mosaic revival' of the 1860s, he was commissioned by the South Kensington Museum and the Palace of Westminster.

In recognition of his experience and talents as an artist and teacher, Poynter was elected President of the Royal Academy in December 1896, was knighted the same year and became a baronet in 1902. He died on 26 July 1919 at his studio house in Kensington and was buried in St Paul's four days later. His pall-bearers included his nephews the novelist Rudyard Kipling and future prime minister Stanley Baldwin. His grave ledger bears the coat of arms granted to him in 1902, the crest amended by him in 1904.

*Self Portrait*, 1882 (Aberdeen Art Gallery and Museums)

Grave ledger by Arthur Green, black marble inlaid with brass, 1929

SIR EDWARD JOHN POYNTER B?
G·C·V·O : K·B : D·C·L : Litt. D :&c.&c.
PRESIDENT OF THE ROYAL ACADEMY
1896 – 1918
DIRECTOR OF THE NATIONAL GALLERY
1894 – 1904
DIRECTOR FOR ART & PRINCIPAL OF
THE NATIONAL ART TRAINING SCHOOL
1875 – 1881
FIRST SLADE PROFESSOR OF FINE ART
AT UNIVERSITY COLLEGE LONDON
1870 – 1875
BORN 20 MARCH 1836
DIED 26 JULY 1919
WHATEVER IS WORTH DOING IS WORTH DOING WELL

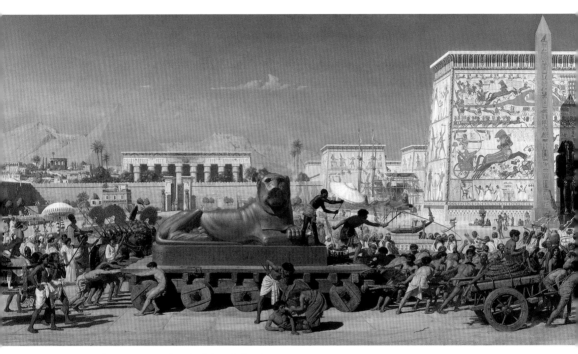

*Israel in Egypt*, 1864–7, detail (Guildhall Art Gallery)

# JOHN SINGER SARGENT

## 1856–1925

BEST known for realist society portraits capturing the likeness and mood of wealthy Edwardian patrons, Sargent was also a prolific and brilliant watercolourist, producing images of his family, friends, architecture and nature on his extensive travels. He also forayed in to mural work and sculpture, and was an official war artist in the later stages of his career. Sargent is the only artist in Artists' Corner to be memorialised by his own work.

Born in a Florentine villa to American parents, his ancestry and identity remained important to him throughout his life. His youth was spent seasonally between northern and southern Europe. In 1874 he sought professional art training from Charles Durand in Paris while enrolling at the École des Beaux-Arts. A visit to Spain in 1879, where he copied works by Velázquez, was to be a life-long influence. In France he had befriended Monet and fellow expatriates such as the artist Edwin Austin Abbey and the novelist Henry James, who helped to promote him in England following his move there in 1885.

In 1890, tempted by the possibilities of history painting on a grand scale, Sargent embarked on a controversial mural scheme, *The Triumph of Religion*, for Boston Public Library. This preoccupied him for over 30 years and was incomplete at his death. The work features a sculpted 'Crucifix' element, presenting Adam and Eve receiving the blood of Christ on the Cross.

In addition to the plaster and wood relief in situ, Sargent commissioned bronze casts of his sculpture; only one was made to scale and was presented to St Paul's, as his own memorial, by his sisters. It was unveiled in the crypt on 15 June 1926. Sargent had died unexpectedly in his sleep on 15 April the previous year and had been buried in Brookwood Cemetery in Woking, Surrey.

*Self Portrait*, 1886 (Aberdeen Art Gallery and Museums)

Memorial cross by John Singer Sargent, bronze, 1897–9

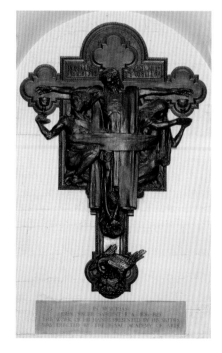

*Triumph of Religion: The Dogma of Redemption*, 1895–1903
(Boston Public Library)

# SIR WILLIAM HAMO THORNYCROFT

## 1850–1925

THORNYCROFT was a dynamic force for change in British sculpture, his bronze and marble figures breaking with convention as he pursued greater realism in representation and controversial subject matter. He was responsible for some of the best-known statues in London.

After his sculptor parents failed to dissuade him from following their example, Thornycroft trained in the family studio and enrolled at the Royal Academy Schools. There he met Frederic Leighton, whom he described as an inspiring master. Influenced at first by a study of the Ancient Greeks and the classic school of Flaxman and Alfred Stevens, he produced a number of statues of classical and Old Testament figures.

On travels to France he found a shift from classicism to realism in the work of François Rude and Paul Dubois, and in Italy he encountered the work of Michelangelo and Donatello. Synthesising these influences on his return, he produced the lifelike and vital figure of the 'mower', soon followed by the 'sower'. His realistic rendering of agricultural labourers was a dramatic contribution to the burgeoning New Sculpture movement, which he shaped with his friend Edmund Gosse.

Commissions for public sculpture proliferated from 1899 and included statues of Alfred the Great and General Gordon, besides many busts and smaller works. The Creighton memorial, made for St Paul's Catheral, portrays the bishop wearing a rolling cope, a crosier in his left hand. Here Thornycroft demonstrates some of the influence of the Italian Renaissance he had absorbed on his travels, entirely appropriate for Creighton, a historian of the period.

Thornycroft died in a nursing home on 18 December 1925 and was buried in Wolvercote church, Oxford. His memorial tablet, unveiled on 24 October 1932 by Lord Edward Gleichen, had been funded by the Royal Society of British Sculptors, of which Thornycroft had been Vice-President. Charles Hartwell, who made the monument, had been one of his pupils.

Portrait by Theodore Blake Wirgman, 1884 (Aberdeen Art Gallery and Museums)

Memorial by C.L. Hartwell, bronze and marble, 1932

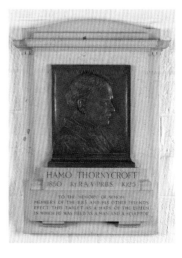

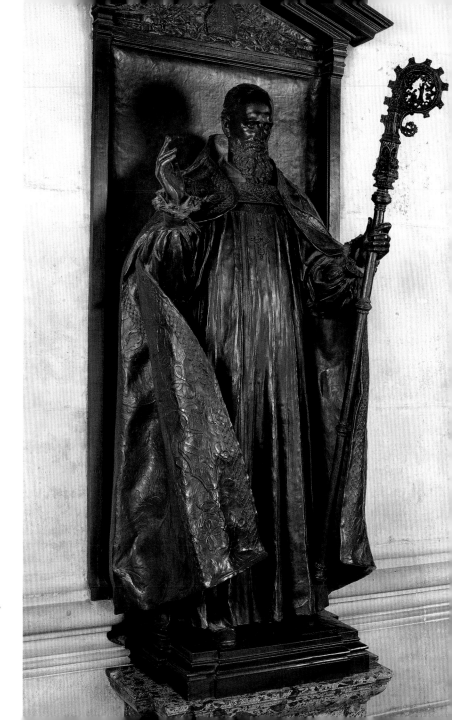

*Dr Mandell Creighton,
Bishop of London
1896–1901*, bronze
and marble, 1905

# SIR GEORGE FRAMPTON
## 1860–1928

ONE of the most influential sculptors of the 'New Sculpture' movement of the late nineteenth century before his star dwindled in the shade of modernism. The son of a stonemason, Frampton was exposed to the skill of carving from an early age. After studying at South London Technical Art School, the Royal Academy Schools and in the studio of Antonin Mercié, his career began with architectural decoration at the Town Hall in Paris. His later move towards sculpture was, he said, a result of encountering ecclesiastical monuments. He produced many memorial works throughout his career, including an ornate grave cover and relief portraits commemorating Edward Vansittart Neale, Richard Seddon, Walter Bessant and George Williams in the crypt at St Paul's.

Portrait by Meredith Frampton, 1919 (National Portrait Gallery)

Wall monument by Ernest Gillick, freestone and bronze, 1930

As advocates of the 'New Sculpture', Frampton, Alfred Gilbert and Hamo Thornycroft turned their backs on the perceived elitism and dullness of mainstream Victorian sculpture, taking their lead from mavericks of the previous generation such as Leighton and Stevens. In particular, Frampton became associated with the closely related movements of the Arts and Crafts and Symbolism, wrote extensively and exerted influence over the *Jugendstil* decorative style in Germany. He was elected to associate membership of the Academy in 1894 and full Academician status in 1902, knighted in 1908 and appointed President of the Society of British Sculptors in 1911. He died on 21 May 1928 and was cremated at Golders Green Crematorium, where his ashes are laid in a niche in the Ernest George Columbarium.

His memorial plaque at St Paul's was commissioned by Lady Frampton and depicts a Lost Boy from the story of *Peter Pan* by J.M. Barrie, holding a miniature of Frampton's best-known work, *Peter Pan*. The original sculpture had appeared mysteriously in Kensington Gardens on the morning

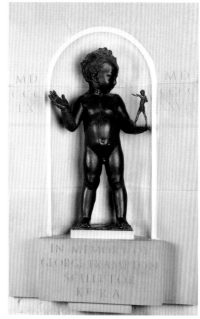

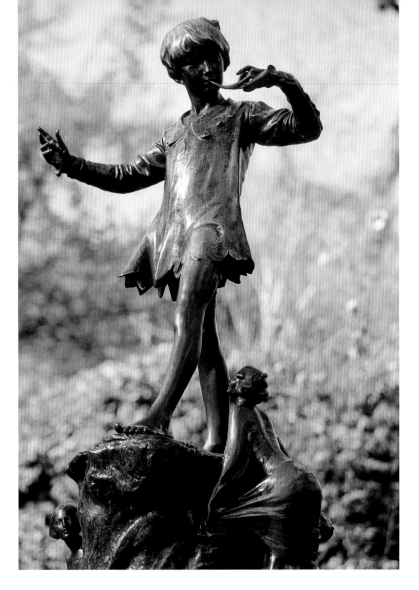

of 1 May 1912. It had been commissioned by J.M. Barrie, who erected it without permission and announced his gift in *The Times* the next day. Frampton depicted Peter in his nightshirt, standing boldly on a tree stump alive with animals and fairies. Immensely popular with Londoners, full-size casts can be seen in Australia, Belgium, America and Canada.

*Peter Pan*, Kensington Gardens, 1912

# SIR FRANCIS DICKSEE

1853–1928

DICKSEE studied in the studio of his father, Thomas, who painted portraits and historical genre scenes; he then enrolled at the Royal Academy Schools and was granted a studentship in 1891. There he was taught by Frederic Leighton and John Everett Millais, whose influence became deeply embedded in his work.

Millais in particular introduced him to the concepts initiated by the Pre-Raphaelite Brotherhood, which combined devotion to detail and the vibrant depiction of the natural world with a medievalising tendency and links to Romantic poetry. Art patron Sir Henry Holland, under whom Dicksee worked, was also closely associated with the original Brotherhood.

*La belle dame sans merci*, Dicksee's best-known work, encompasses many Pre-Raphaelite concepts. It was inspired by a ballad by John Keats recounting the tale of a knight enchanted by a fairy femme fatale who leads him to his doom. The subject had been painted by five other Pre-Raphaelite enthusiasts, however Dicksee's is perhaps the most successful, demonstrating his skill at orchestrating colour and composition. He returned to the theme of the perceived dangers of female sensuality in *The Confession,* a moralising work set in his own time.

Despite considering themselves reformers, the Pre-Raphaelites were frequently criticised for being backward-looking. Dicksee was himself a staunch opponent of developments in modern art, which he deplored as 'the cult of ugliness'. He turned his style to society portraits, which frequently used compositions already established by his art heroes.

In his later years he enjoyed a number of honours, being elected President of the Royal Academy in 1924, receiving a knighthood in 1925 and becoming a Knight Commander of the Royal Victorian Order in 1927.

*Self Portrait*, 1883 (Aberdeen Art Gallery and Museums)

Wall memorial designed by Mervyn Macartney, made by Broadbent & Sons, stone, 1930

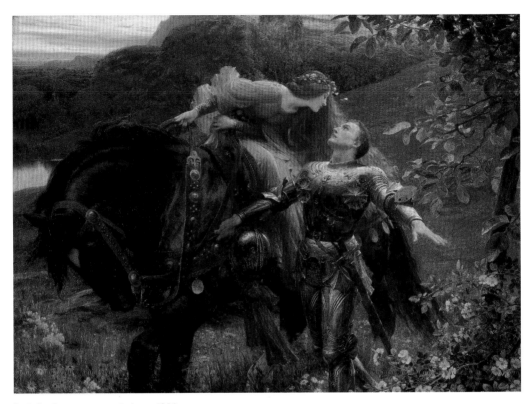

*La belle dame sans merci*, about 1901
(Bristol Museum and Art Gallery)

His obituary in *The Times* recognised that Dicksee outlived the golden
age of his preferred style but observed that his presidency had been deserved
on the basis of his 'personality, manners, tact, general culture and popularity
as a man'. Dicksee died in a nursing home in October 1928. His memorial was
unveiled by Sir William Llewellyn on 8 May 1930 at a dedication ceremony
conducted by the Dean.

# SIR ALFRED GILBERT
1854–1934

ALFRED Gilbert was a highly inventive and experimental sculptor. A key figure of the 'New Sculpture' movement, he achieved success through his mastery of materials, innovation and risk-taking, yet his fame was achieved at great personal cost.

An unruly son of musicians, Gilbert enrolled at the Royal Academy Schools but quickly became disillusioned by the quality of the sculpture tuition. He worked part-time in the studios of established sculptors and in 1872 became an assistant to Joseph Edgar Boehm. The two shared studio space and collaborated on works including the memorial to their friend Francis Holl for the crypt of St Paul's.

At Boehm's suggestion Gilbert continued his education at the École des Beaux-Arts in Paris, accompanied by his first cousin, Alice, whom he married on the day of departure. The couple spent nine years on the Continent in a period of 'idealism and peaceful contentment', which both would later miss. In Rome Gilbert studied Renaissance sculpture by Donatello, Cellini and Giambologna, whose works he emulated in some of his most successful statuettes.

Returning to England in 1885, Gilbert became fascinated with new materials and techniques. He trained as a goldsmith and was the first artist to use aluminium. This material can be seen on his monument to Caldecott in the crypt of St Paul's and also on his best-known work, the Shaftesbury Memorial, popularly known as 'Eros', made for Piccadilly Circus in London. Greatly appreciated today, it was not an immediate success: critics were scathing and Gilbert found himself liable for the cost of materials, which plunged him in to debt.

Gilbert was elected a Royal Academician in 1892 and became a well-known presence on the London art scene. However, his tendency towards perfectionism was antithetical to swift delivery, which led to growing disgruntlement among his clients. In 1908 he was forced to resign from the Royal Academy.

Having sought refuge in Bruges in 1901, where he

Photograph by Ralph Winwood Robinson, about 1889 (National Portrait Gallery)

Wall memorial by Gilbert Ledward, stone and bronze, 1936

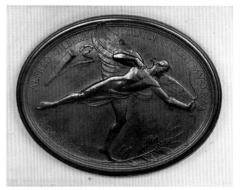

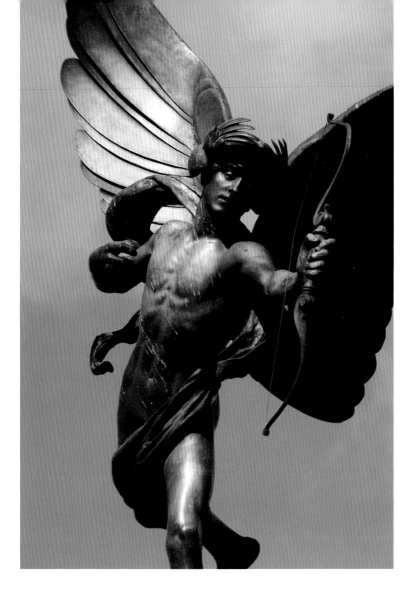

lived in an impoverished state, he was eventually rehabilitated, largely through the efforts of the journalist Isabel McAllister, who would write his biography. He was subsequently knighted and re-elected to the Royal Academy; he died in 1934. Although he was an atheist, his memorial service was held in St Paul's on 13 November and his memorial plaque was installed two years later.

The Shaftesbury Memorial, 'Anteros', Piccadilly Circus, 1892–3

# SIR WILLIAM LLEWELLYN
## 1858–1941

UNCERTAINTY over William Llewellyn's birth date, even at the time of his death, is indicative of the opacity of his early life. Born in Cirencester, at some point he made his way to London, where he trained under Edward Poynter at the National Art Training School.

After study in Paris, Llewellyn began exhibiting at the Royal Academy in 1884 and soon after turned to portrait painting as a profession. He produced formal portraits of establishment figures – mayors, aldermen, judges and military men – as well as a few coastal landscapes. He was commissioned to paint his only royal subject in 1911, for which Queen Mary sat twice at Buckingham Palace. Many copies were made and the work became the official image of Queen Mary throughout the British Empire.

Elected an associate of the Royal Academy in 1912, Llewellyn became a visiting professor and a full Academician in 1920. His presidency, from 1928 to 1938, was characterised by the co-ordination of blockbuster exhibitions that drew enormous attendance. For a 1930 exhibition of Italian art the loan of works from Italy by Raphael, Botticelli, Mantegna, Masaccio and Titian was brought about by the personal intervention of Mussolini. The paintings were transported to and from Italy in a specially chartered vessel, which temporarily ran aground on the return voyage. Also during Llewellyn's presidency, Dame Laura Knight was elected an Academician – the first woman to join since the two female founder members; Knight's appointment led to three resignations.

In later life Llewellyn received many honours, both in England (such as his KCVO) and abroad (Grand cross of the Crown of Italy), and he became a Trustee of the National Gallery. He died at home in 1941 and his funeral was held at Westminster Abbey. The memorial erected in his honour in the crypt of St Paul's Cathedral in 1942 was unveiled by his successor as President of the Royal Academy, Edwin Lutyens.

Portrait by Bernard Partridge, 1928 (National Portrait Gallery)

Memorial by Charles Wheeler, stone, 1941, sculpted by Curtis Green, 1942

*Portrait of Queen Mary,*
*1911–12 (Royal*
*Collections Trust)*

# PHILIP WILSON STEER
## 1860–1942

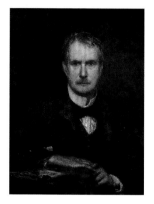

STEER was an early champion of Impressionism in Britain and applied the radical new style to his coastal and countryside scenes and figure studies. He later moved to a more traditionally English form of representation, producing canvases and watercolours of windswept skies, castles and valleys, heavily influenced by Turner and Constable. He was Professor of Painting at the Slade School of Fine Art for 27 years.

His father was a painter and art teacher but it was the family nurse, Mrs Raynes (subsequently his housekeeper), who presented him with his first box of watercolours; she would later be the subject of one of his best portraits. After attending the drawing school of the Department of Science and Art, Steer was refused entry to the Royal Academy Schools and went instead to Paris, then the undisputed centre of the European art world. On his return he became a founding member of the New English Art Club in opposition to the attitudes of the Academy.

Summer painting excursions to Walberswick in Suffolk produced beach scenes saturated with atmosphere and light, akin to the work of Monet, while elaborate nudes evoked other French artists. At first his work found a hostile reception; however, in the 1890s he gained support from critics including Dugald Sutherland MacColl, a watercolourist and Keeper of the Tate Gallery (1906–11), who became his life-long friend and biographer. Steer's transition to more conventional landscapes occurred around the turn of the century and continued until his death.

Steer died of bronchitis at his home in London on 21 March 1942. The return to a native style, his commission as a war artist in 1918 and receipt of the Order of Merit helped to secure Steer's reputation. However, on his death it was MacColl who coordinated the funding, design and placement (next to Constable) of a monument. MacColl also gave the address at the unveiling of the monument in the crypt on 27 October 1943.

*Self Portrait*, 1920 (Fitzwilliam Museum, Cambridge)

Memorial by E.R. Bevan, Hopton Wood stone, 1943

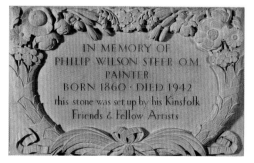

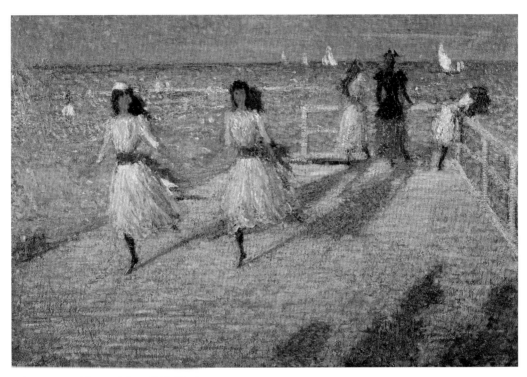

*Girls Running, Walberswick Pier*, 1888 (Tate)

# SIR MUIRHEAD BONE
## 1876–1953

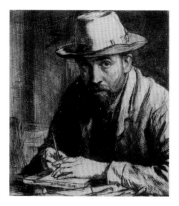

BONE specialised in drawings, etchings and watercolours. He was born in Glasgow and was inspired by the city in which he grew up, then approaching the peak of its industrial and commercial prosperity. He was fascinated by the docks and railway stations, the demolition of old buildings and the construction of new ones, which he described as having 'a strange new poetry and romance'.

Drawing classes at school were followed by evening classes at Glasgow School of Art but he remained largely self-taught and decided to become a professional artist. He moved to London in 1901, where he built a reputation as a first-class draughtsman and printmaker.

On 12 July 1916 Bone was appointed Britain's first war artist. He was chosen for his ability to quickly sketch high-quality drawings that could be easily reproduced and disseminated. He worked on the Western Front, producing at least 143 drawings in his first two months. His output was subject to a strict control: he could not depict dead bodies or images of troops being killed, and therefore focused on the destruction war left behind. When military censors lifted the ban on images of tanks, which hitherto had been considered a secret weapon, he was able to produce one of his best-known drawings, *Tanks*.

After the war he travelled extensively in Europe, particularly Italy and Spain, with his wife, the author Gertrude Bone. He applied himself to the foundation of the Imperial War Museum and assisted refugee charities. With the outbreak of the Second World War he joined the committee for selecting a new group of war artists and was commissioned again to contribute to the official record of the war effort.

Bone died of leukaemia in October 1954 and was buried at St Mary's Church, Whitegate, Cheshire. A service paper in the cathedral archives records that the memorial tablet in St Paul's was unveiled and dedicated at noon on 15 November 1954. Professor Gilbert Murray, a leading humanist, spoke at the ceremony.

*Self Portrait*, 1908 (Hunterian Art Gallery, Glasgow)

Wall memorial by Charles Holden, black marble, 1954

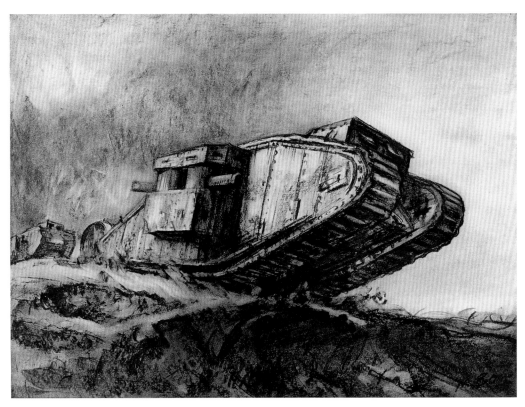

*Tanks*, 1918 (Imperial War Museum)

# SIR MAX BEERBOHM
## 1872–1956

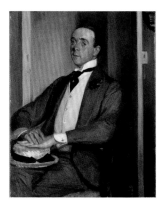

HENRY Maximilian Beerbohm was equally distinguished in writing and caricature. Famous by 24 and retired to Italy at 38, his exaggerated drawings recorded and parodied hundreds of the leading political and cultural personalities of his day. His brilliance for likeness, humour and imagination lifted his caricatures to the realm of art and his works can be found in many public collections.

Beerbohm identified his day school in Orme Square, London, as the birthplace of his drawing habit. This continued at Charterhouse School, where he filled his books with caricatures of fellow students, teachers and public figures. At Merton College, Oxford, where he studied Classics, he met the novelist Reggie Turner, who introduced him to the circle of Oscar Wilde.

His professional art career began in 1892, when *The Strand* magazine published a series of his drawings of 'Club Types', taking them to a wide audience and dealing his modesty 'a great, an almost mortal blow'. His work appeared in *The Yellow Book*, *The Sketch* and the *Pall Mall Budget*, before he published books dedicated to his drawings. One of his most successful, *The Poets' Corner* (1904), was a rare departure into the caricature of historical figures and included Byron whom he found one of the most interesting characters of the 19th century. Favourites among his contemporary targets were the Pre-Raphaelites, Rudyard Kipling and the Prince of Wales. His drawings were frequently accompanied by texts: his writing was generally noted for its elegance, clarity and wit.

He died in Rapallo, Italy, on 20 May 1956. He was cremated at Genoa and his ashes were interred at St Paul's on 29 June. A plaque was unveiled in the cathedral on 12 April 1962 by the publisher Sir Sydney Roberts, who observed: 'Had Max been told that he was to be commemorated in St Paul's he would have received the news with wide-eyed astonishment'. A tile marked 'MB' denotes the location of his ashes.

Portrait by Jacques-Émile Blanche, 1903 (Ashmolean Museum, Oxford)

Wall memorial by Alan Reynolds, slate and marble, 1961

MAX BEERBOHM

*Caricaturist and Writer*

1872 – 1956

*Lord Byron shaking the dust of England from his shoes.*

# SIR ALFRED MUNNINGS
## 1878–1959

A PROLIFIC painter of horses, country life and landscapes, Munnings captured the world of his aristocratic patrons and actively participated in the country pursuits he portrayed. His love of rural life and traditional approach to representation in art brought him into conflict with the challenges of social change, mechanisation and avant-garde artists.

Horses were central to his upbringing in Suffolk, where they provided transport, agricultural power and sport. As a child he drew them from memory or his imagination and gradually developed his talent. He studied at the Norwich School of Art and, having successfully submitted work to the Royal Academy in 1899, he continued his studies at the Académie Julian in Paris.

At the outbreak of the First World War Munnings was unable to join the army owing to the loss of sight in one eye in a riding accident. However, in 1918 he was appointed civilian official war artist to the Canadian Cavalry Brigade and the Canadian Forestry Corps in France. The work he produced further established his success and helped to secure his admittance to the Royal Academy in 1919.

Elected a full Academician in 1925, Munnings became the Royal Academy's most controversial President. In an explosive speech at a banquet he attacked the abstract tendencies of modern art, singling out Picasso, Matisse and Cézanne. He subsequently retired to spend more time at the races – and produced three volumes of autobiography.

Munnings died in his sleep in 1959. After a private cremation at Colchester, Essex, his ashes were interred in the crypt at St Paul's, where his memorial plaque was deliberately placed next to that of John Constable (with whom he shared a love of the Suffolk countryside). A memorial service was held a week later in St James's Piccadilly. Unveiling the memorial tablet on 3 June 1960, Sir Charles Wheeler, President of the Royal Academy, said: 'With passionate zeal, he fought the good fight for those values he believed to be true, and he feared nothing as much as to paint a thing badly'. The inscription was provided by Munnings's friend, the Poet Laureate John Masefield.

Portrait by Maurice Frederick Codner, about 1944, detail (Munnings Art Museum, Dedham)

Wall memorial designed by Sir Edward Maufe RA, sculpted by William McMillan RA, stone, 1960

ALFRED JAMES MUNNINGS K.C.V.O.
1878 – 1959
PRESIDENT OF THE
ROYAL ACADEMY OF ARTS
1944–1949
O friend, how very lovely are the things
The English things you helped us to perceive

*The Horse Fair (A Suffolk Fair)*, 1904 (Norfolk Museums Service)

# SIR WILLIAM REID DICK
## 1878–1961

ONE of the foremost British sculptors of the early twentieth century, Dick developed his highly successful career in inter-war London. He produced portrait busts, war memorials, architectural sculpture and statuettes, employing elements of the sculptural traditions of the past and his own innovative stylisation of form.

Dick grew up in a tenement block in Glasgow as the city filled with buildings clad in public sculpture. With limited formal education, he became an apprentice stonemason; while carving for the Kelvingrove Art Gallery he met the sculptor George Frampton, who had designed the building's sculptural scheme. Dick began attending Glasgow School of Art shortly afterwards.

From 1908 onwards he regularly exhibited at the Royal Academy and the Paris Salon, and his reputation grew quickly. Returning from service in the First World War, he won a number of prominent commissions: a lion for the Menin Gate at Ypres, Belgium; an eagle for the RAF memorial on Victoria Embankment, London – and a group for the Kitchener Memorial Chapel in St Paul's Cathedral. He worked closely with Mervyn Macartney, the cathedral surveyor, on the latter project, an exemplar of his belief that sculpture was at its best when related to architecture. The work was a critical success, and a copy of the *Pietà* (much influenced by Michelangelo's) was given a prominent position at the 1925 Paris Exhibition. The low relief frieze of dancing putti, entitled *New Life,* was based on Donatello's *Cantorie* (singing galleries).

As well as becoming an Academician, Dick was a Trustee of the Tate Gallery and President of the Royal Society of British Sculptors. He also served on the Royal Fine Arts Commission and was King's Sculptor in Ordinary to Scotland. He died at home on 1 October 1961 and was cremated at Golders Green Crematorium. His memorial plaque at St Paul's was unveiled on 17 October 1963 during a dedication ceremony attended by artists and architects. The President of the Royal Academy, Sir Charles Wheeler, gave the oration.

Portrait by Reginald Grenville Eves, 1933 (National Galleries of Scotland, Scottish National Portrait Gallery)

Wall memorial by Alan Reynolds, slate, 1963

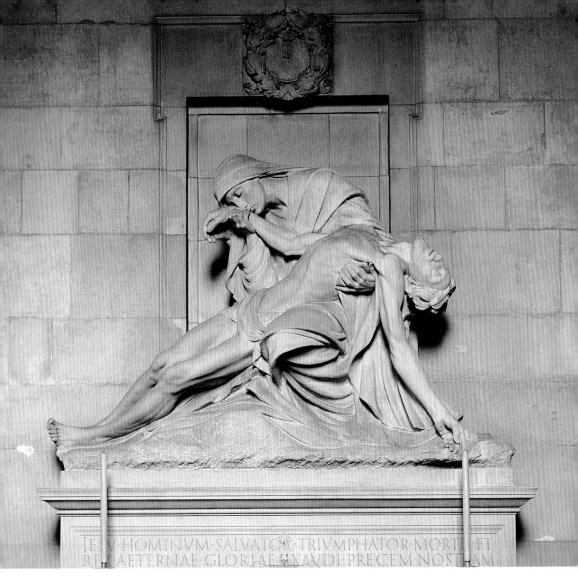

*Pietà*, Kitchener Memorial Chapel, Portland stone, 1925

# SIR GERALD FESTUS KELLY

## 1879–1972

DESCRIBED by contemporaries as 'the most reliable portrait painter of his time', Gerald Kelly excelled despite having no formal art training; he championed art and artists throughout his life.

In spite of a serious childhood illness, Kelly had, by his own admission, a lucky life. Educated at Eton and then Cambridge, where he read English Literature, he only turned seriously to painting after moving to Paris in 1900. The stimulating environment sprang him out of his lethargy and he started to paint in earnest.

A cousin introduced him to the art dealer Paul Durand-Ruel, who promoted his works and they met with immediate success.

While in Paris he befriended the writer Somerset Maugham, who financed trips to Burma and Cambodia, where Kelly produced landscapes and portraits of dancers. In exchange, Kelly provided Maugham with material for his writing. Kelly also sought out the great artists of Europe. His unsolicited house calls on French masters such as Cézanne and Degas received a mixed welcome. Although he met the foremost Impressionists, it was the works of Velásquez and Ingres that remained his greatest inspiration.

In 1920 Kelly married Lilian Ryan, a young artist's model, who first sat for him in 1916. He painted her more than fifty times in the course of their happy marriage. He always referred to her as Jane and the paintings were titled *Jane I, Jane II, Jane III* and so on when they were exhibited at the Royal Academy. Other sitters included King George VI and Queen Elizabeth II, T.S. Eliot and Ralph Vaughan Williams.

Kelly held a number of official positions at the Royal Academy before he was elected President in 1949. His predecessor, Alfred Munnings, had been opposed to modern art but Kelly adopted a more conciliatory approach. He organised some outstanding exhibitions and became an art commentator on BBC television and radio.

He died at home in London. His funeral took place at Golders Green Crematorium on 7 January 1972, with a memorial service held at St James's Piccadilly. His memorial tablet at St Paul's was unveiled by Thomas Monnington on 22 November 1973.

Portrait by Oswald Birley, 1920 (National Portrait Gallery)

Wall memorial tablet by David McFall, limestone, 1973

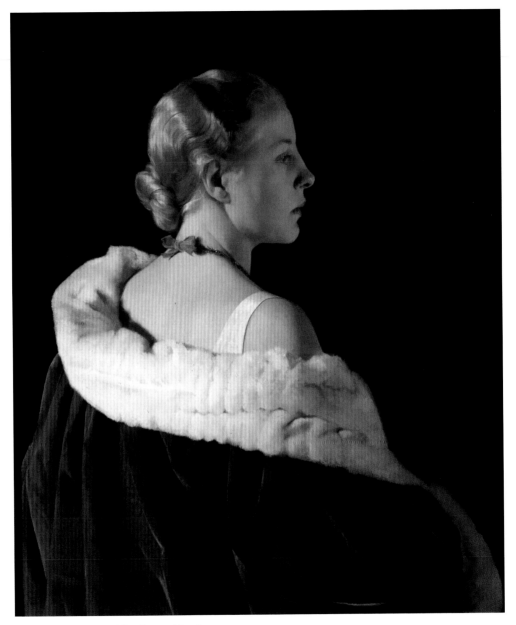

*Jane XXX*, 1930 (Royal Academy of Arts)

# SIR CHARLES THOMAS WHEELER
## 1892–1974

THE gentle modernism of Charles Wheeler's sculpture can be found on the exterior of some of London's major architectural landmarks. He also made medals, elements for war memorials, stone and bronze gallery works and several portraits, including that of T.E. Lawrence. He was the first sculptor to be President of the Royal Academy.

Portrait photograph by Rex Coleman, 1962 (National Portrait Gallery)

Wall memorial by Willi Soukop, limestone, 1976

*The Old Lady of Threadneedle Street* Bank of England front façade, 1934

Wheeler grew up in Wolverhampton, where he attended the local art school; he went on to enrol at the Royal College of Art. Taught by the French sculptor Édouard Lantéri, he later identified the Croatian Ivan Meštrović and Swede Carl Milles as other important influences on his work. Unable to fight during the First World War, he made prostheses for amputees. In the Second War he was an official war artist commissioned to produce busts of the admiralty. Post-war he contributed to numerous public memorials, including those to the Royal Navy, the Merchant Marine and the RAF in Malta.

Collaboration on the Winchester College memorial began a close friendship with the architect Herbert Baker, with whom he worked on the new Bank of England. This was the most extensive scheme of the era and secured his reputation and finances. He went on to embellish India House, South Africa House, Church House and the Trafalgar Square fountains, as well as a statue of Emmanuel Kwasi Kotoka for Accra airport in Ghana.

As President of the Royal Academy Wheeler inherited difficult financial conditions, oversaw 35 exhibitions, and the controversial sale of a Leonardo da Vinci cartoon. He suffered a stroke and died on 22 August 1974 and was buried at St Luke's Church, Codsall. A memorial service was held in the crypt of St Paul's on 10 December 1975 and his memorial tablet was unveiled at a service of dedication 10 May 1977. Wheeler's work can be seen in four memorial panels in the cathedral: the plaque for William Lewellyn (1941); low-relief profile portraits of Wilson Carlile (1943) and William Inge (1955); and a plaque to the stonemasons of St Paul's (1968).

CHARLES THOMAS WHEELER
KCVO CBE
1892 – 1974
SCULPTOR

PRESIDENT OF THE ROYAL ACADEMY
1956–1966

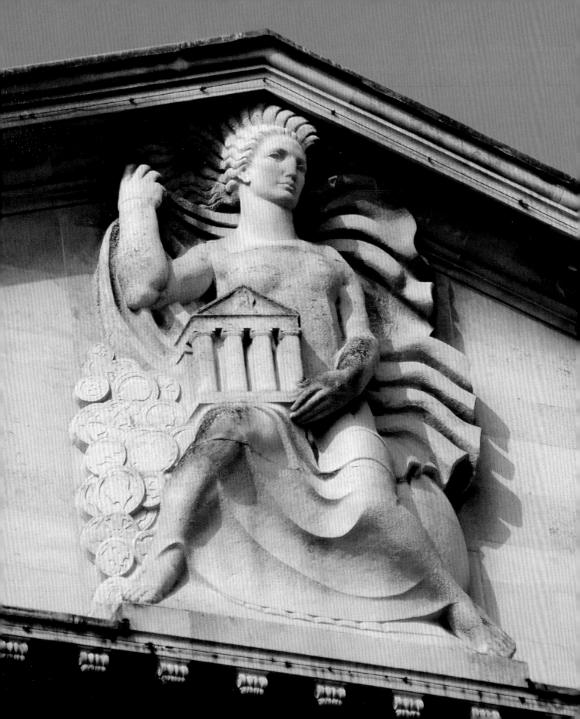

# SIR THOMAS MONNINGTON
## 1902–1976

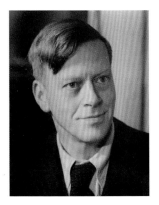

THOMAS Monnington grew up in Sussex and began to teach himself to draw and paint at the age of 12, while resting for a heart complaint. He attended the Slade School of Fine Art in 1918–22, followed by a three-year scholarship at the British School in Rome. While in Italy he was deeply influenced by the artists of the fifteenth century, particularly Piero della Francesca. Here he met and married his first wife, the artist Winifred Margaret Knights, and produced his first large work, *Allegory*, now in the Tate collection.

Portrait photograph by Howard Coster, 1955 (National Portrait Gallery)

Wall memorial by Willi Soukop, limestone, 1980

On returning to London Monnington began teaching at the Royal Academy Schools and the Royal College of Arts and collaborated on large-scale works for the Bank of England and the Houses of Parliament. In May 1939 he joined the Ministry of Defence's camouflage team, which strengthened his existing interest in a scientific approach to the arts. For the next four years he was chiefly responsible for designing camouflage for aircraft production sites. He wrote a proposal to document the war in the air and in November 1943 became an official war artist.

Although he produced fewer works after the war, the direction of Monnington's art was dramatically altered as he began to explore mathematical and geometrical designs. In 1953 he was commissioned by the Edwin Austin Abbey Memorial Trust to paint the ceiling of the conference hall of the Civic Centre in Bristol, for which he created an abstract, geometric pattern inspired by the atomic age, which he painted directly on to the ceiling.

Monnington was elected President of the Royal Academy in December 1966 – the first PRA to produce abstract art – and he was knighted the following year. He was a highly effective President, doing much to restore the Academy's ailing fortunes against a backdrop of financial difficulty.

He died at home on 7 January 1976. His private funeral was followed by a memorial service at St James's Piccadilly and his memorial plaque was unveiled in St Paul's on 11 March 1980.

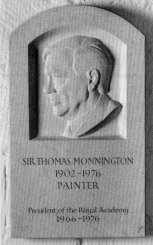

SIR THOMAS MONNINGTON
1902–1976
PAINTER

President of the Royal Academy
1966–1976

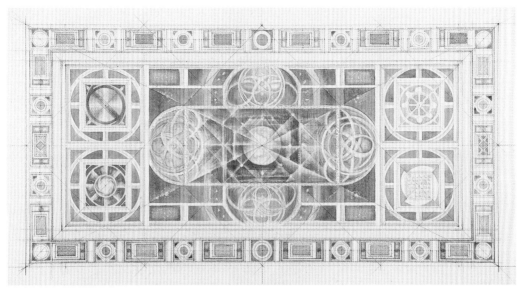

Design for the Bristol conference hall ceiling, 1956 (Bristol Museums)

# HENRY MOORE
## 1898–1986

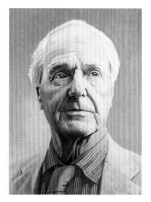

MOORE was one of the most important British sculptors of the twentieth century. The ubiquity of his works in public places around the world today belies the impact of his inventiveness to modern art in Britain.

He absorbed the style and spirit of the European avant-garde in his youth and was encouraged by his teachers to pursue art training. After active service in the First World War he studied first at Leeds School of Art and then the Royal College of Art. His early sculptures took inspiration from non-Western traditions and 'primitive' art, which he encountered on visits to the British Museum, and the work of Picasso and the Surrealists.

His first exhibitions met with a mixed reception, with one newspaper campaigning for his removal as an art teacher. However, by 1940 his reputation was sufficiently established for him to become an official war artist. His drawings of the London Underground shelters are poignant records of the effects of a bombing campaign on a civilian population. From the end of the Second World War his output was dominated by his two self-confessed obsessions: the reclining figure and the mother and child group, both of which he explored tirelessly throughout his middle and later career.

His mother and child group in St Paul's is unusual among Moore's work in that it is intended to convey a religious meaning. Installed on 26 March 1984, the piece had been carved at the Henraux stoneyard in Querceta, in the Carrara Mountains of central Italy. In discussions before the arrival of the work the Cathedral Chapter noted that the sculpture was not intended as an exhibit but rather as 'an object of spiritual evocation, needing a private rather than public site'.

Moore died at home in August 1986 and his funeral was held on 4 September at St Thomas's Church, Perry Green; a service of thanksgiving took place at Westminster Abbey on 18 November 1986. In 1987 his daughter, Mary, approached St Paul's with a proposal for a simple memorial tablet in limestone to commemorate her father. This was unveiled two years later.

Portrait by Dario Mellone, 1989 (Leeds Museum and Galleries)

Wall memorial by David Kindersley, stone, 1989

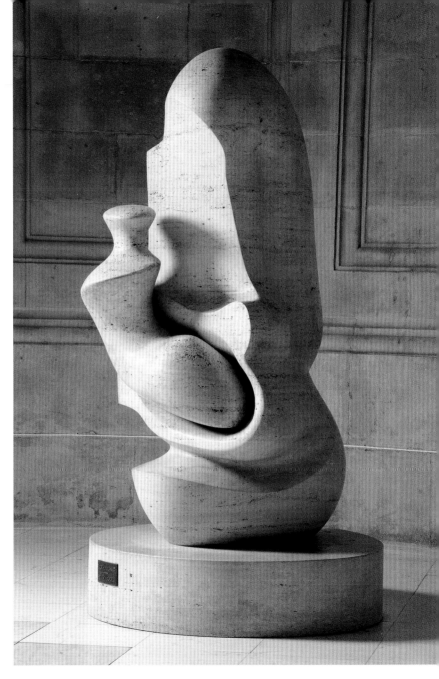

*Mother and Child: Hood,*
1986 (St Paul's
Cathedral)

# SIR ROGER DE GREY
## 1918–1995

A PAINTER and art teacher who favoured views of the French and British landscape, de Grey became the twenty-first President of the Royal Academy, where his reforms helped to strengthen and modernise the institution.

Born in Buckinghamshire, he survived an unhappy time at Eton College thanks in part to the Assistant Drawing Master, Robin Darwin. Darwin encouraged him to continue his studies at Chelsea School of Art and later employed him as an art lecturer at King Edward VII School of Art. Following promotion to Master of Painting there, de Grey moved to London and became a senior tutor at the Royal College of Art. His career was interrupted by the Second World War, during which he saw action as a captain and married fellow artist and Royal Academician Flavia Irwin. His presidency of the Academy (1984–93) was notable for its ambitious exhibitions programme, focusing on individual artists such as Monet and Chagall as well as thematic shows such as *The Age of Chivalry*, which showcased European Gothic art, and *The Art of Photography*.

De Grey was inspired by his uncle, Spencer Gore, and shared his enthusiasm for the work of Paul Cézanne. De Grey's later blue-green landscapes, made in Kent and the South-West of France, reflect this. He described his working method as observing nature, 'its colour sensations extracted' on the spot, with 'the addition of textual complexity taking place in the studio'. The studio became a subject in its own right as de Grey explored the relationship between internal and external space and how the two could be represented simultaneously on canvas.

He died on 14 February 1995 and a memorial service was held at Southwark Cathedral. His monument, installed in 2002, brings to an end the almost complete line of Presidents of the Royal Academy memorialised at St Paul's Cathedral.

*Self Portrait*, 1990, detail (National Portrait Gallery)

Wall memorial by Spencer de Grey, slate, 2001

1918 - 1995

ROGER
de GREY
KCVO PRA

*painter*

*Var Valley I*, 1967 (Government Art Collection)

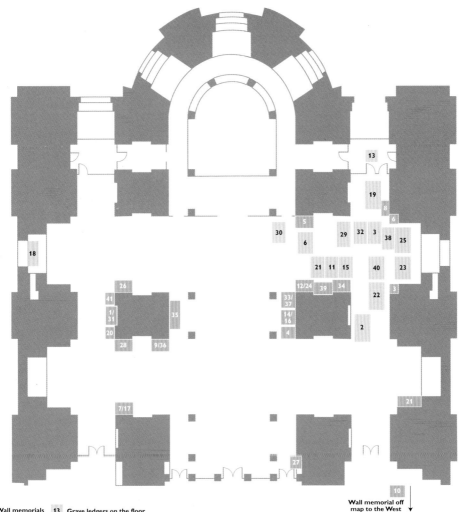

27 **Wall memorials**    13 **Grave ledgers on the floor**

Wall memorial off
map to the West

1 Edwin Austin Abbey
2 Sir Lawrence Alma-Tadema
3 James Barry
4 Sir Max Beerbohm
5 William Blake
6 Sir Joseph Edgar Boehm
7 Sir Muirhead Bone
8 Randolph Caldecott
9 John Constable
10 George Cruikshank
11 George Dawe

12 Sir Francis Dicksee
13 John Henry Foley
14 Sir George Frampton
15 Henry Fuseli
16 Sir Alfred Gilbert
17 Sir Roger de Grey
18 Francis Montague Holl
19 William Holman Hunt
20 Sir Gerald Festus Kelly
21 Sir Edwin Landseer
22 Sir Thomas Lawrence

23 Sir Frederic Leighton
24 Sir William Llewellyn
25 Sir John Everett Millais
26 Sir Thomas Monnington
27 Henry Moore
28 Sir Alfred Munnings
29 John Opie
30 Sir Edward Poynter
31 Sir William Quiller
   Orchardson
32 Sir Joshua Reynolds

33 Sir William Reid Dick
34 George Richmond
35 John Singer Sargent
36 Sir Philip Wilson Steer
37 Sir William Hamo
   Thornycroft
38 Joseph Mallord William
   Turner
39 Sir Anthony Van Dyck
40 Benjamin West
41 Sir Charles Thomas Wheeler